Advertising Clocks

America's Timeless Heritage

Michael Bruner

With Price Guide

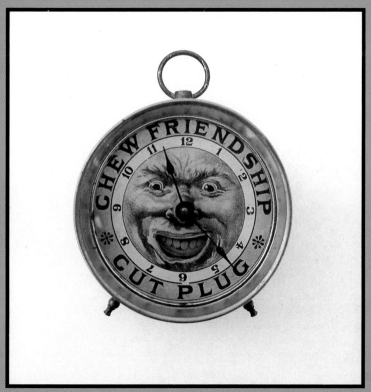

77 Lower Valley Road, Atglen, PA 19310

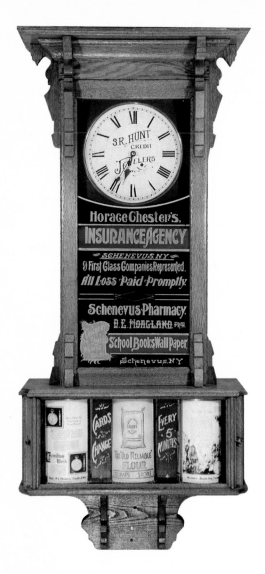

Copyright 1995 by Michael Bruner

Printed in Hong Kong
ISBN: 0-88740-790-0

Library of Congress Cataloging-in-Publication Data

Bruner, Michael.
 Advertising clocks: America's timeless heritage: with price guide / Michael Bruner.
 p. cm. -- (A Schiffer book for collectors)
 Includes bibliographical references and index.
 ISBN 0-88740-790-0 (soft)
 1. Advertising clocks--United States--Catalogs. I. Title. II. Series.
NK7500.A38B78 1995
741.6'7'0973075--dc20 95-6994
 CIP

Dedication

To my dearest friend
David A. Meyer,
September 21, 1952 - January 13, 1994.

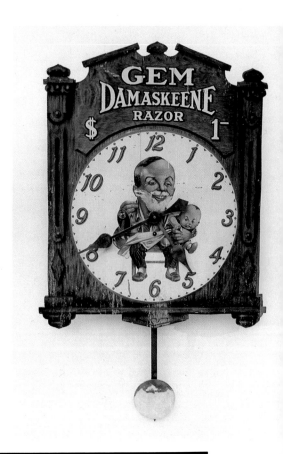

Published by Schiffer Publishing, Ltd.
77 Lower Valley Road
Atglen, PA 19310
Please write for a free catalog.
This book may be purchased from the publisher.
Please include $2.95 postage.
Try your bookstore first.

We are interested in hearing from authors
with book ideas on related subjects.

Special Thanks and Acknowledgements

Much of the credit for a completed book should be given to the dozens of thoughtful people that helped *"behind the scenes."* Most of these individuals were responsible for sharing their collections and time to make this book possible. I'd like to take a moment and acknowledge certain key people that helped with their special talents and encouragement to bring together this first ever book on American Advertising Clocks.

To Peter Schiffer, my publisher, and Douglas Congdon-Martin, my editor, my sincere appreciation for your support throughout this project.

To Jim Humphrey and Bernie and Annette Nagel, whose companionship in this hobby helped me get through the enduring moments.

To Carl Barrow, who taught me a thing-or-two about just how much is really out there!

To Jerry and Millie Maltz, my sincere thanks for allowing me into your home to photograph your fabulous collection, and for all your help with historical information.

To Sharon Callender and the crew at Drayton Printing and Copy Center, for your assistance with text layout.

To John R. Heafield at PHOTOFAST, Birmingham, Michigan, whose outstanding photofinishing is used in the majority of my photographic work.

And finally to all my contributors, it was rewarding to meet with all of you and photograph your collections. You have made this book a reality.

Mike Bruner

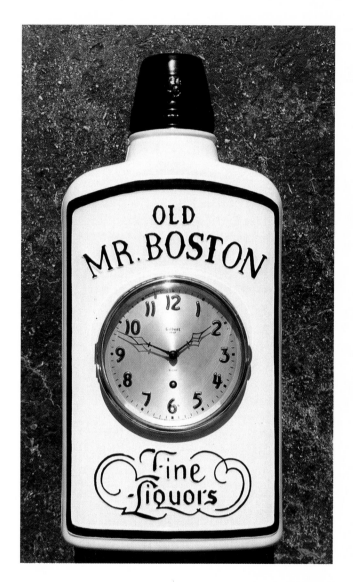

Old Mr. Boston is bigger than life on this large spring wound clock which takes the shape of their well-known product.

Contributors

The following is an alphabetical listing of contributors that have shared their time and allowed me to photograph items contained in this book. Some individuals wish to remain anonymous, and their contributions are much appreciated.

Antique Mall of Manitowoc, Manitowoc, Wisconsin

Automobile Collectibles, Belmont, Michigan

Ken Baisa of Ken-Glo Clocks, San Carlos, California

Carl Barrow, Martinsville, Virginia

Earl Bender, Bixby, Oklahoma

Roger Blad, Burnsville, Minnesota

Trudy Bridge, Trego, Wisconsin

Bill and Karen Brown, Ochelata, Oklahoma

Don Brunjes, Long Beach, New York

Canal Park Antique Center, Duluth, Minnesota

Betty Case, Broken Arrow, Oklahoma

Nick Conner, Rice Lake, Wisconsin

Leslie and Donna Deason, Moberly, Missouri

Trish Duque, Baird, Texas

Fox River Antique Mall, Appleton, Wisconsin

Nancy Golpe, Manistique, Michigan

Luther and Murphy Gordon, Waterford, Michigan

John R. Heafield at Photofast, Birmingham, Michigan

Dave Higgs, Wayne, Michigan

Donna and Jim Hillstrom, Manitowoc, Wisconsin

Harold and Joanna Huddleston, Denton, Texas

Jim Humphrey, Swartz Creek, Michigan

Eugene and Mary Ann Jarusinski, Duluth, Georgia

Mike Johnson, Memphis, Missouri

John H. Johnson, Memphis, Missouri

Charles Kleeberg, Tacoma, Washington

Bob Kozar, Saint Paul, Minnesota

Dave and Kathy Lane, Tulsa, Oklahoma

Frank Liska, Colorado Springs, Colorado

Jerry and Millie Maltz, New Rochelle, New York

Memories Antique Mall, Appleton, Wisconsin

Suzan and Max Mendlovitz, San Antonio, Texas

Gary Metz, Roanoke, Virginia

Bernie and Annette Nagel, White Lake Township, Michigan

Bob Nelson, Saint Paul, Minnesota

Dan Oberholtz, Kansas City, Missouri

John and Cindy Ogle, Grand Island, Nebraska

Olde Orchard Antique Mall, Egg Harbor, Wisconsin

Old Towne Antique Mall, Kewaunee, Wisconsin

Gary Parker, Grand Island, Nebraska

Steve Perrigo, Independence, Missouri

John A. Perrino, Middletown, New York

Vivian and Bob Plunkett, Superior, Wisconsin

Dick and Kathy Purvis, Manchester, Connecticut

Railroad Memories Museum, Spooner, Wisconsin

Vic and Sara Raupe, Guthrie, Oklahoma

Red Barn Antiques, Ephraim, Wisconsin

Randy Reith at The Last Filling Station, Van Buren, Arkansas

W.K. Richards at Oakwood Antique Mall, Raleigh, North Carolina

Darcy Salbert at Neon Images, Lincoln Park, Michigan

Gene Sonnen, Saint Paul, Minnesota

Bruce Stevens and Sons, Lafayette, Indiana

Superior Antique Depot, Superior, Wisconsin

Robert Taylor at Retro Antiques, Duluth, Minnesota

Darryl Tilden, Minneapolis, Minnesota

Topeka Antique Mall, Topeka, Kansas

Dennis and Jeanne Weber, Saint Joseph, Missouri

Dan and Nancy Wessel, Jacksonville, Illinois

Wizard Art Works, Tulsa, Oklahoma

Bill and Jane Wrenn, Oxford, North Carolina

Jon and Mary Wyly, Platte City, Missouri

Contents

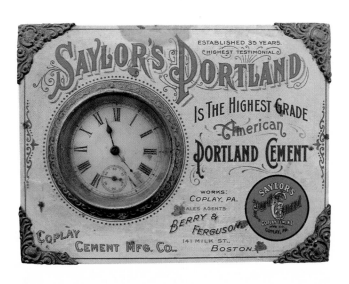

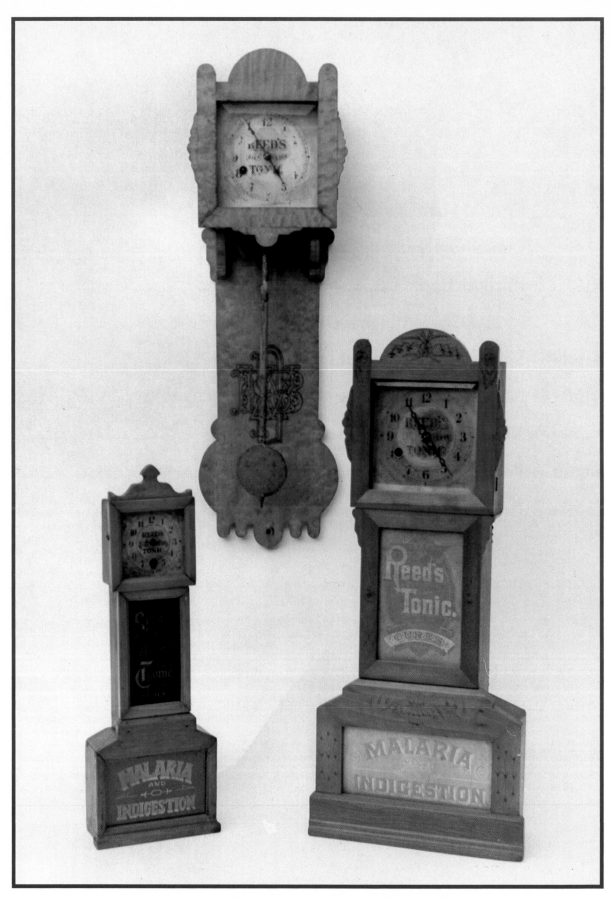

This gorgeous trio of early Reed's Tonic clocks dates to the
1870s, and are part of the fantastic collection of Jerry and Millie
Maltz.

Introduction

As the many forms of advertising became commonplace through the years, few were as noticed as those found on the dials of America's clocks. Everything we do is in some way affected by the need to know time, and merchants needed a timepiece, prominently placed, to operate an efficient business. American advertisers were quick to realize this, and began to place emphasis on clock advertising even prior to the 20th century.

The first significant clock advertising seems to date from 1870 to 1900. This should not be too surprising though, as the industrial revolution turned small manufacturers into production giants. Products that previously were sold in bulk containers and barrels were changing over to individual packaging. New products entered the marketplace so fast that manufacturers were finding every possible place to spread the word. Clocks were viewed as an effective and inexpensive means to bring manufacturers and consumers together.

As the years progressed, nearly everyone who had a product or service to offer was advertising on clocks. From the largest companies to small town shops, the retailers of America made advertising clocks commonplace. The 1900s saw the gradual introduction and acceptance of electricity by America's clock manufacturers. Pendulum and spring wound clocks were gradually being replaced with electric movements. Wood case clocks began to give way to the use of metal fabrication, and eventually these were replaced by synthetics such as pressed board and plastics.

In spite of the many changes in America's buying habits, the use of clocks as an advertising medium has endured. World wars and depressions have had little impact on the significance of clocks as a way to market products and services. Because of this, there is a heritage covering over a century of advertising clocks presented in this book. This is a *"timeless"* view of how clocks became a major player in American Advertising.

The Clock Makers: Over 100 Years of Design

Many of the trade names used on advertising clocks through the years are household words. Most major American manufacturers were at some point using clocks to get their message to the public. However, few people gave a second thought to the companies that produced these clocks. As with all mass produced items, certain manufacturers were dominating the market. In fact, many of the companies that produced advertising clocks were either started as an advertising clock maker, or eventually manufactured only advertising clocks.

The first *"giant"* in the business was the **SIDNEY CLOCK CO.**, of Sidney, New York. These beautiful wooden case pendulum movement clocks were used in the 1880-1900 era, and featured three rotating drums at the base of the clock. Finely detailed woodwork and beautiful graphics have put the Sidneys in historic perspective as the *"kingpin"* of all advertising clocks.

The **BAIRD CLOCK MANUFACTURING CO.**, was founded in 1888 in Montreal, Canada and moved to Plattsburgh, New York in 1890. It became the first mass producer of advertising clocks. Most of these had a round clock dial with an advertising marquee around its perimeter, and a lower section with a round advertising marquee. The most notable feature of the clocks was their construction, wood cases with papier-mache door advertising marquees and paper-on-wood dials. Baird did, however, manufacture more conventional clocks with all wood cases and metal dials when they moved their operations to Evanston, Illinois in 1900.

As the 20th century took shape things were rapidly changing in the clock manufacturing business. Electricity gave advertising clocks new possibilities. No more springs to wind! Simply plug it in and it does the rest. With the conversion to electric designs, movements became smaller, and the clocks became lighter. They also became less expensive to manufacture, and this gave a big push to the many advertisers in the marketplace to get their message across via clocks.

In the 1920s neon tubing was first used in the advertising world. Theaters, billboards, big signs and small — everything was tried in neon. It didn't take long for neon to find its way to clocks. One of the early large manufacturers of neon clocks was **NEOCRAFT** of Elkhart, Indiana. Their clocks featured a *"spinner"* that moved as a second hand in front of a neon tube. Another prominent manufacturer was the **CLEVELAND CLOCK CO.** of Cleveland, Ohio. They incorporated neon behind plastic for a stunning *"glow"* effect. Many of their clocks were also made with a round marquee. These normally would encircle half the diameter of the clock and were back-lit with neon tubing.

In the 1940s, silk screening techniques for back-lit dial clocks were perfected. Beautiful images were incorporated that looked great in daylight and simply came alive at night. There were two giants that emerged in the back-lit dial clock industry — **PAM CLOCK CO.** of New Rochelle, New York, and **TELECHRON, INCORPORATED** of Ashland, Massachusetts. Both of these companies produced advertising clocks in the tens of thousands and their legacy is that they were the largest suppliers of electric advertising clocks in the world. Their high quality, more than their relatively recent vintage, has left a lasting impact on advertising clock collectors.

In spite of the fact that there is a one-hundred-plus year history in the advertising clock market, few items have surfaced for collectors that would be considered go-withs. Almost every manufacturer produces illustrated catalogs of their product line, whatever it is. Certainly advertising clock manufacturers should have catalogs. But where are they? The author would be most interested in hearing from anyone that has any catalogs or advertisements showing advertising clocks. In the meantime, enjoy this photo essay of clocks with a message. Although it portrays only a fraction of the thousands of advertising clocks made in America, it will give you an idea of the beauty and diverse graphics to be found in this very collectible part of Americana.

I look forward to hearing from you. Please feel free to write me, c/o 5585 Wildrose, West Bloomfield, MI 48322.

Mike Bruner

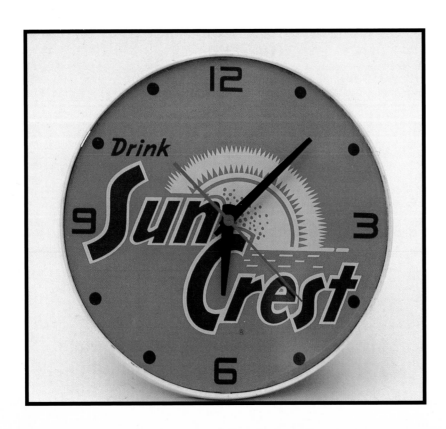

Chapter 1
Spring Wound Pendulum Clocks

The advertising clocks found in this chapter are spring wound and employ a pendulum. Manufacturers built pendulum type movements in advertising clocks starting around 1870 and they continued to be produced well into the 20th century. Clocks in this early era will be found in a wide variety of shapes and styles, and will mostly have wood case construction. It is interesting to note that no weighted movements are to be seen in this chapter. Possibly clock manufacturers found spring wound mechanisms easier to build and more acceptable to advertisers.

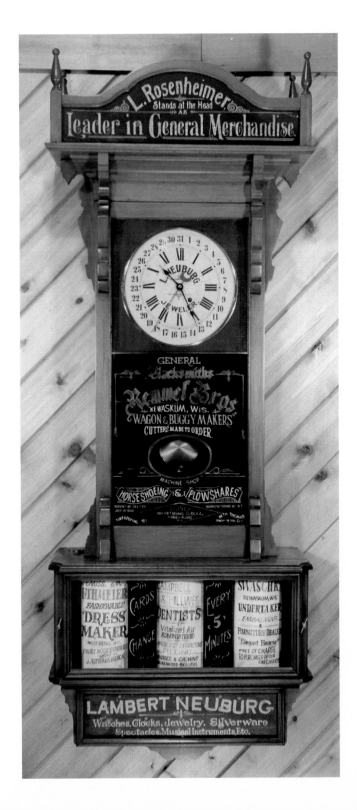

This beautiful Sidney advertising clock was manufactured in the 1880s. Like all Sidney clocks, it features advertising from several businesses. Not only does the clock display advertising from three different companies on the reverse painted glass, but the three drums seen near the bottom actually revolved every five minutes and gave a new message. Each drum could display in three different positions, so there could be up to nine displays on the drums. Add all this up and this Sidney clock had twelve advertisements, not forgetting that you would get the correct time as well! These fantastic clocks were a magnificent work of art, and were the pinnacle of craftsmanship in the wood case clock industry in the 19th century. The example shown here measures 28" x 59". *Courtesy of John A. Perrino.*

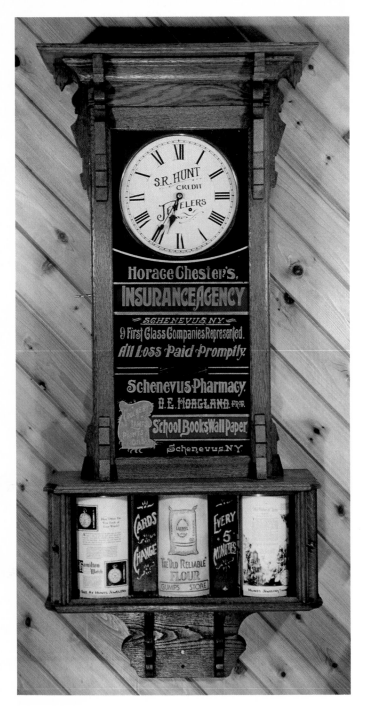

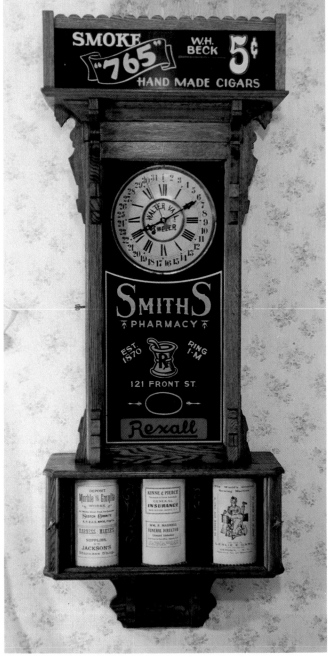

Two advertisers were featured on the reverse painted glass shown here. Nine advertisements are on the rotating drums. Notice that the clock dial has the name of a jeweler displayed. No doubt they were the distributor for these clocks and could economically get their message across on every clock they sold. This example measures 28" x 59". *Courtesy of John A. Perrino.*

Our final example of these wonderful clocks features two advertisers on reverse painted glass. Notice that *"Rexall"* was already in the public eye even at this early period. Again, there are nine advertisers featured on the rotating drums. Like all Sidney clocks, the casework was an individual statement of craftsmanship, as no two seem to be alike. What a wonderful legacy to leave to the American people — these clocks are truly *"timeless."* Measures 28" x 59". *Courtesy of John A. Perrino.*

Baird Clock Manufacturing Company produced this clock in the 1890s. The frame is of wood construction and the circular advertising area is made of papier-mache. There is a small glass window through which the pendulum could be observed. There were hundreds of similar clocks produced by Baird, each having a different advertisement. It measures 19" x 31". *Courtesy of John A. Perrino.*

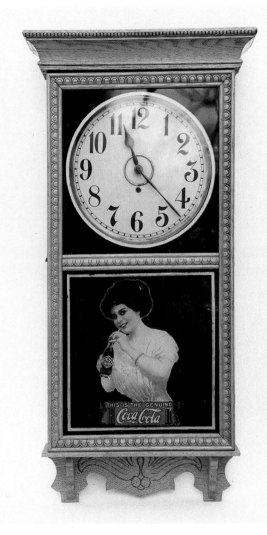

The Ingraham Company of Bristol, Connecticut, was the manufacturer of this fantastic wood case Coca-Cola clock. The reverse painted glass window featuring a woman holding an early style bottle of the famous soft drink helps date the clock to around 1915. It measures 17" x 40". *Courtesy of Jerry and Millie Maltz.*

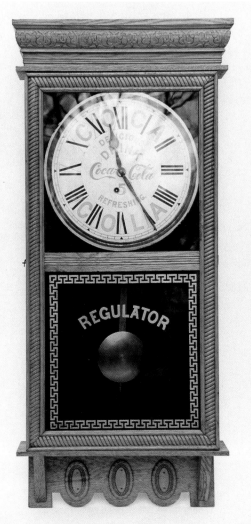

Here's another early wood case clock on the Coca-Cola theme. Made by the Ingraham Company of Bristol, Connecticut, it dates to around 1915. It was just about impossible to read the time without seeing the advertising on this one. It measures 17" x 40". *Courtesy of Jerry and Millie Maltz.*

Marks Arnheim was a tailor in an unknown city that is featured on this beautiful clock dial. This is our first example of using the advertiser's product or service name in place of numbers that are normally found around the dial. This technique continues even today as a means to focus attention on the product. Built by Seth Thomas in the 1880s. It measures 16" x 31". *Courtesy of Jerry and Millie Maltz.*

Your first reaction to this photograph might be to think that the negative had been reversed. A closer examination will reveal that only the numbers are backwards, as the words *"Kramer Service Company, Elkader, Iowa"* read as normal. This unusual clock was manufactured specifically for use in barber shops, so that a mirror could be used between the clock and viewer. Not only are the numbers backwards, but the mechanism runs backwards as well. It measures 14.5" x 22" and dates to around 1924. *Courtesy of Jerry and Millie Maltz.*

This early Reed's Gilt Edge Tonic clock dates from the 1870s, with an exposed pendulum. It measures 8" x 28". *Courtesy of Jerry and Millie Maltz.*

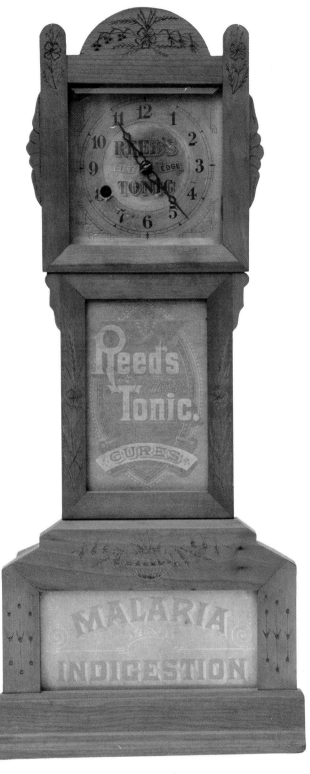

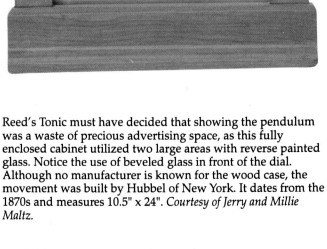

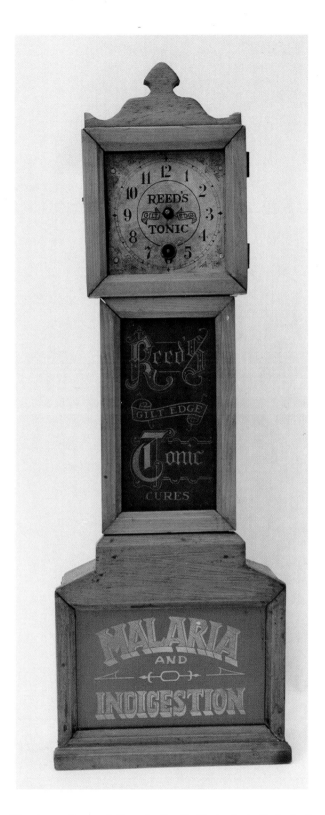

Reed's Tonic must have decided that showing the pendulum was a waste of precious advertising space, as this fully enclosed cabinet utilized two large areas with reverse painted glass. Notice the use of beveled glass in front of the dial. Although no manufacturer is known for the wood case, the movement was built by Hubbel of New York. It dates from the 1870s and measures 10.5" x 24". *Courtesy of Jerry and Millie Maltz.*

Here's another variation of a Reed's Tonic clock. Each clock was hand built, so no two would be exactly alike. The word *"cures"* would have been a popular belief in the 1800s, as many advertisers took advantage of the lack of government control in medicines. That changed in 1906 with the intervention of the Pure Food and Drugs Act by Congress. This example was a small one, measuring only 6" x 17.5". It dates to the 1870s. *Courtesy of Jerry and Millie Maltz.*

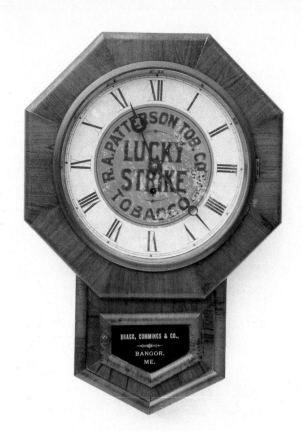

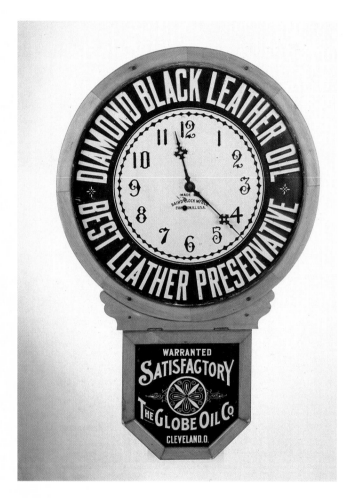

Lucky Strike used this handsome wood case clock around 1900. Bragg, Cummings, and Company of Bangor, Maine, was the case manufacturer. New Haven built the movement. It measures 17" x 24". *Courtesy of Jerry and Millie Maltz.*

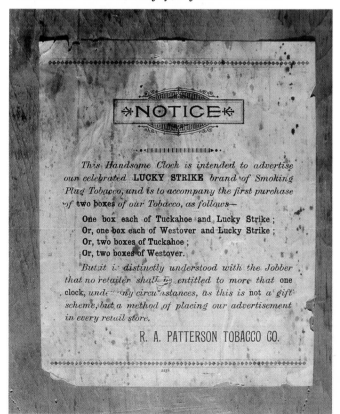

Around 1900 this Diamond Black Leather Oil clock was manufactured by Baird. It features pine case construction with an embossed tin dial. There is an eight-day movement which is signed by Baird. This later style Baird clock also uses a *"schoolhouse"* type bottom, and has a tin advertisement concealing the pendulum. It measures 20" x 30". *Courtesy of Jerry and Millie Maltz.*

Here's a close-up of the label that is attached to the back side of the Lucky Strike clock. Apparently these clocks were given to the retailer as a promotional maneuver.

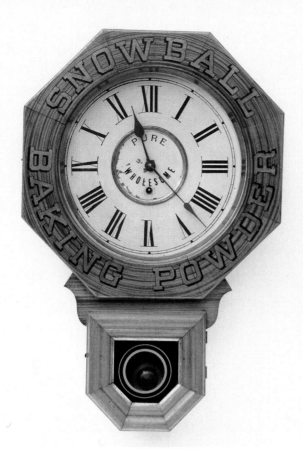

Snowball Baking Powder got their message across on this super wood case clock built by Ingraham. It measures 16.5" x 25" and dates from the 1890s. *Courtesy of Jerry and Millie Maltz.*

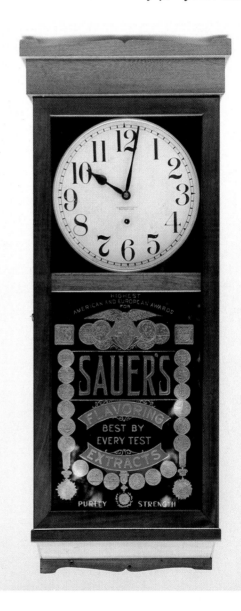

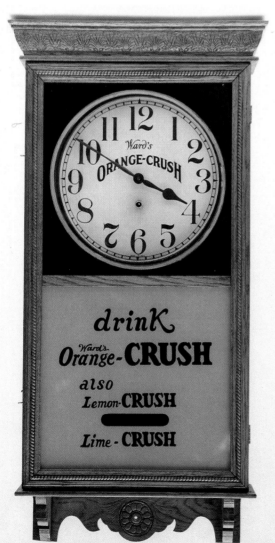

Sauer's Extract took full advantage of the large area of this wood case clock. It measures approximately 14" x 38", and dates to 1915. *Courtesy of Bill and Jane Wrenn.*

Ward's Orange Crush had this easy-to-spot wood case clock made around 1915. It measures approximately 15" x 35". *Courtesy of Bill and Jane Wrenn.*

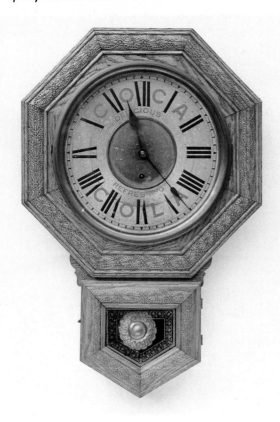

The outstanding Coca-Cola wood case clock pictured here was manufactured around 1903. It measures 18" x 26.5". *Courtesy of Jerry and Millie Maltz.*

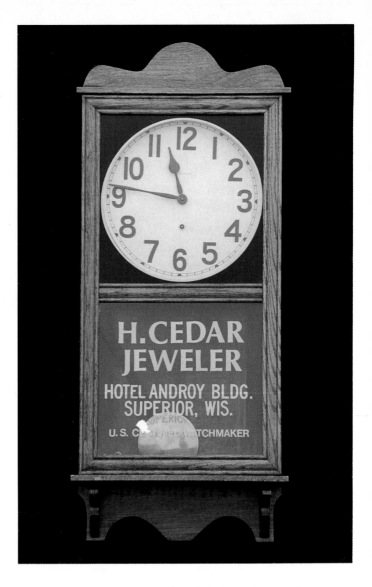

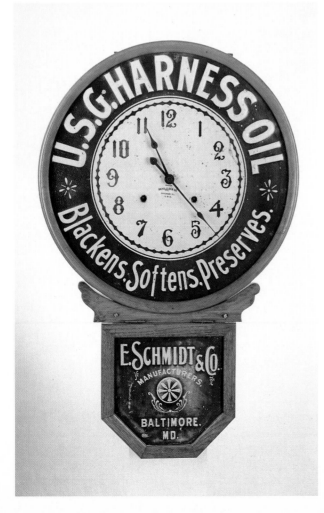

Many small-time businesses found clocks an inexpensive means to advertise their services. This wood case regulator style clock did service for H. Cedar, a jeweler in Superior, Wisconsin. It measures 16" x 38", and dates to around 1925. It was manufactured by New Haven Clock Company, New Haven, Connecticut. *Courtesy of Vivian and Bob Plunkett.*

Here's another example of the beautiful case work found on Baird Clock Manufacturing Company's products. This one was built for U.S.G. Harness Oil, and features a 15-day movement. Again, it has the schoolhouse lower case for the pendulum, which is concealed behind a painted tin advertisement. It measures 20" x 30". *Courtesy of Jerry and Millie Maltz.*

A close-up look at the manufacturer stamping on a Baird clock. *Courtesy of Bernie and Annette Nagel.*

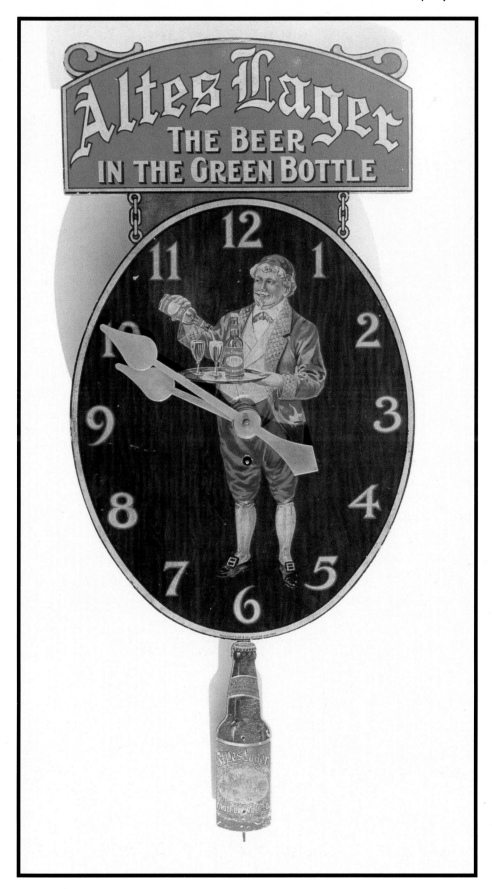

Gorgeous might be the best way to describe this fantastic Altes Lager clock. Its metal construction gave the manufacturer the ability to utilize a die-cut design. Even the pendulum is die-cut in the shape of a beer bottle! For beer company memorabilia collectors, it just doesn't get any better than this! The clock was built by Palm, Fechteler and Company, of Chicago and New York. It measures 15" x 25", and dates to around 1910. *Courtesy of Dick and Kathy Purvis.*

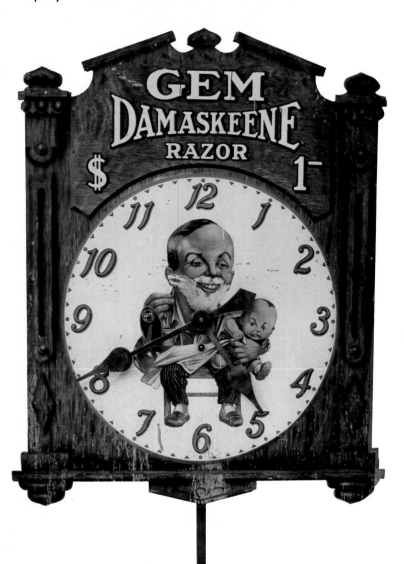

Gem had a winner with this circa 1910 Damaskeene Razor clock. Its somewhat humorous graphics on the dial got the message across that their product offered a safe shave even under the roughest conditions! Manufactured by Sessions of Forestville, Connecticut, it measures 21" x 27.5", without pendulum. *Courtesy of Jerry and Millie Maltz.*

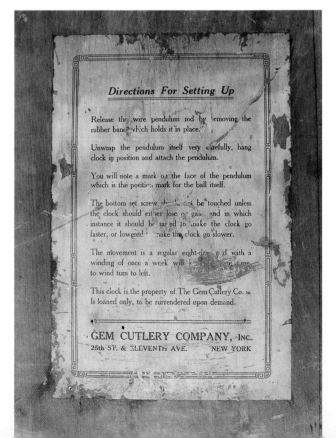

Here's a close-up of the label on the back of the Gem clock. *Courtesy of Jerry and Millie Maltz.*

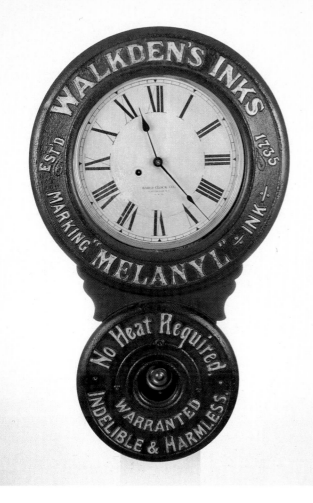

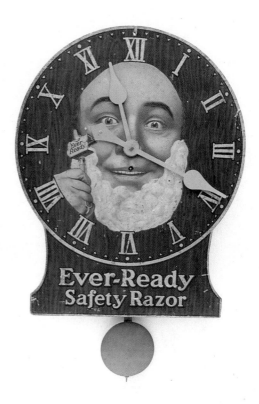

This fabulous Walkden's Inks clock is a perfect representation of the hundreds of similar advertising clocks manufactured by Baird when they were located in Plattsburgh, New York, around 1892 to 1896. It features the usual pine case construction with papier-mache doors. The Roman numeral dial is of paper on a wood backing. One keyhole signifies a mainspring for an eight-day movement, signed by Baird. It measures 18" x 30". *Courtesy of Jerry and Millie Maltz.*

The Ever-Ready Safety Razor clock pictured here is another example of how manufacturers would utilize every inch of available advertising space to create a visual impact. This example dates from around 1910 and measures 18" x 22", without its pendulum. It was manufactured by Sessions Clock Company of Forestville, Connecticut. *Courtesy of Jerry and Millie Maltz.*

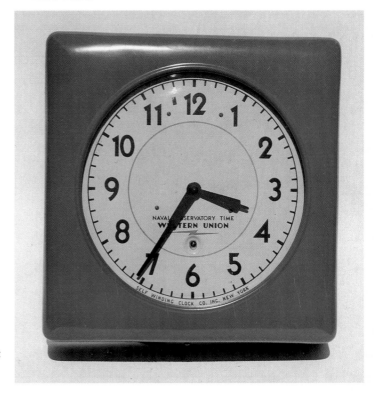

Accurate time keeping was always a priority with Western Union. The Self Winding Clock Company was the manufacturer of several styles of *"impulse"* clocks that reset themselves through the use of an energized signal sent to the movement. The one pictured here measures approximately 16" x 16", but was also made in a larger size. The small light bulb seen below the red lightning bolt would light up when the clock was receiving its reset signal. The timing for the signal originated at the Naval Observatory in Washington, D.C. It dates to the 1930s. *Author's collection.*

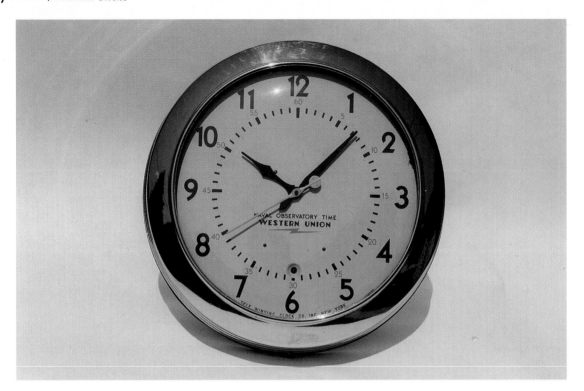

This 1930s model of Western Union clock operated exactly like the one with the red case, but had the added feature of a second hand. Again, the manufacturer is the Self Winding Clock Company. It measures approximately 20" in diameter. *Author's collection.*

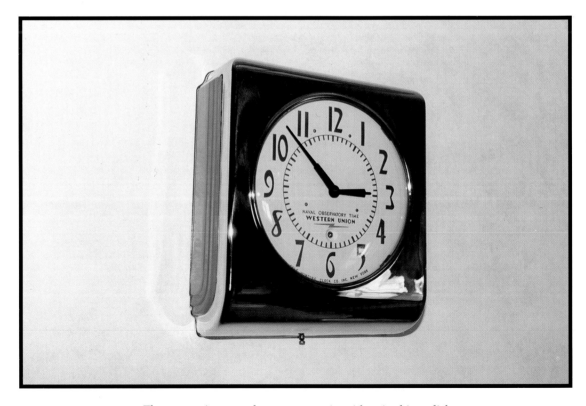

The temptation to make a statement is evident in this stylish art deco Western Union clock. However, its production must have been short-lived, as this model is rare. It measures approximately 16" x 16", and has a similar movement to the other Western Union clocks. *Author's collection.*

Chapter 2
Non-Pendulum Spring Wound Clocks

As the use of pendulum movements lost popularity with advertising clock manufacturers, spring wound mechanisms without pendulums became the standard. Their simple operation and smaller size were a new attraction for America's retailers. The clock manufacturers were equally pleased with their lower cost.

Although the *"heyday"* of spring wound advertising clocks was before 1930, they continued to be manufactured in the following years in lesser quantities.

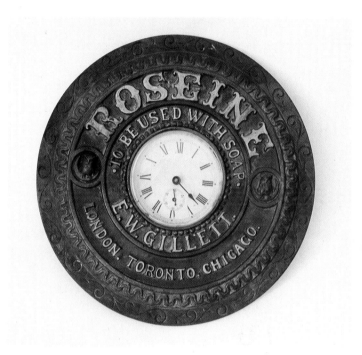

A strong hook would be needed to hold this Roseine advertising clock, as its case is made of cast iron. It measures 11.5" in diameter, and was manufactured by the Regent Mfg. Company of Chicago. It dates to around 1880. *Courtesy of Jerry and Millie Maltz.*

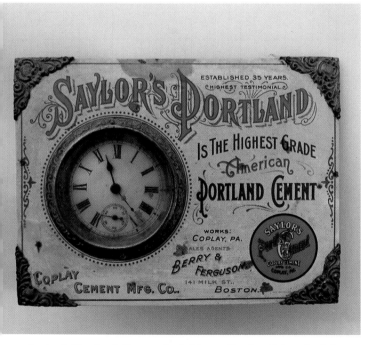

Saylor's Portland Cement had this small advertising clock in use around 1910. It has a cardboard-like front with a metal plate supporting it. This beauty measures approximately 10" x 6", and was designed to be placed on a desk or shelf. *Courtesy of Jerry and Millie Maltz.*

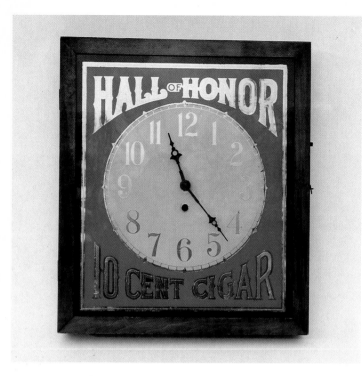

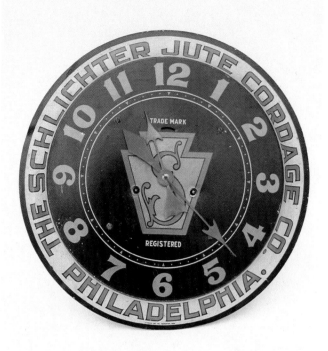

The eye-catching Hall of Honor clock pictured here used a metallic-like reverse paint dial. It measures 15.5" x 18", and dates to around 1910. *Courtesy of Jerry and Millie Maltz.*

It's amazing how certain words seem to go by the wayside with the passage of time. A fine example of this would be the words *"Jute Cordage"* that are found on this circa 1915 advertising clock. If you haven't figured it out, the Schlichter Company were manufacturers of rope. It measures 13.5" in diameter, and was produced by the Standard Advertisement Company of Coshocton, Ohio. *Courtesy of Jerry and Millie Maltz.*

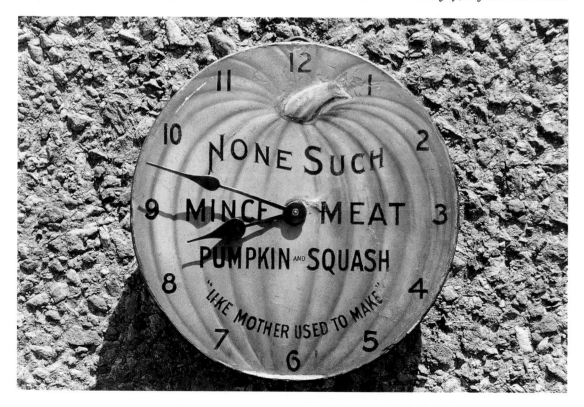

None Such Mince Meat used an appropriate choice of graphics for this circa 1900 metal case clock. It measures approximately 11" in diameter. *Courtesy of Eugene and Mary Ann Jarusinski.*

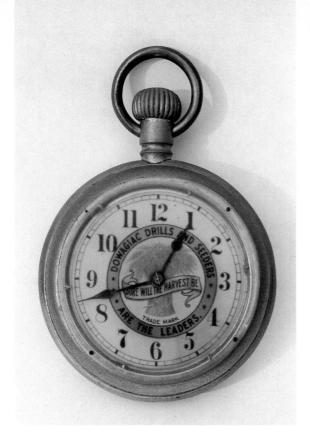

This beautiful advertising clock for Dowagiac Drills and Seeders appears to be pocket watch size, but it actually measures 7.5" x 10.5". Although no location is found for the company, they were likely located in Western Michigan, in a town by the same name. This clock dates to around 1900. *Courtesy of Jerry and Millie Maltz.*

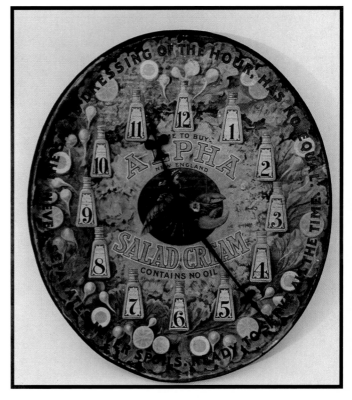

Alpha Salad Cream used a garden theme to create this circa 1890s advertising clock. The dial has numbers inside of dispensers of salad cream, and various garden vegetables around its perimeter. The clock has metal construction with a paper label dial, and it measures 11" x 12". *Courtesy of Jerry and Millie Maltz.*

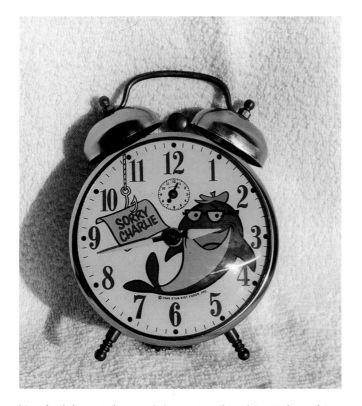

You don't have to be an adult to enjoy the whimsical graphics found on this 1969 Charlie the Tuna clock. We all like clocks with *"good taste,"* this one being no exception. *Courtesy of Luther and Murphy Gordon.*

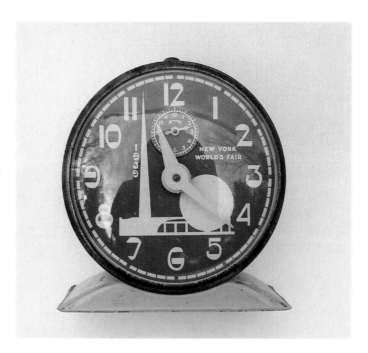

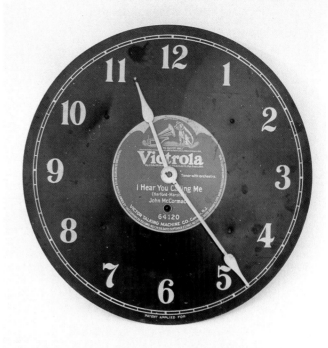

The 1939 New York World's Fair was the theme on this commemorative alarm clock. Like everything else of the period, the *"deco"* look was the *"in"* thing. *Courtesy of Jerry and Millie Maltz.*

Sessions Clock Company of Forestville, Connecticut, may have been the maker of this circa 1925 Victrola clock. It measures 15" in diameter. *Courtesy of Jerry and Millie Maltz.*

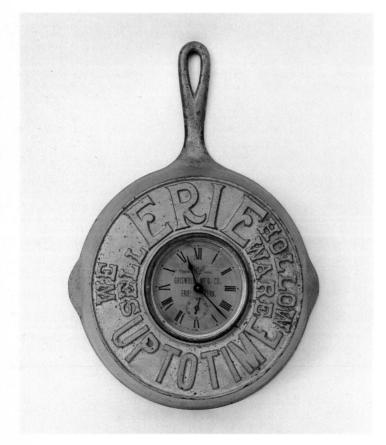

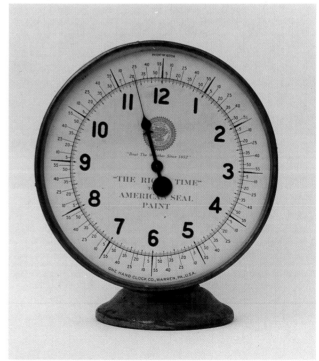

Griswold Manufacturing were the promoters of this super Erie Hollow Ware advertising clock. Yes, it is a full-size frying pan! This one possibly dates as far back as the 1870s. It measures 11" x 14". *Courtesy of Jerry and Millie Maltz.*

This unusual shelf clock was built by the One Hand Clock Company of Warren, Pennsylvania. It carries an advertisement for American Seal Paint, and is quite rare. The dial measures 9" in diameter, and it stands 10.5" high. *Courtesy of Jerry and Millie Maltz.*

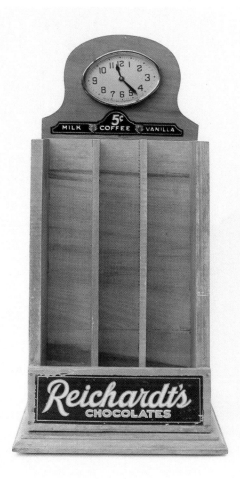

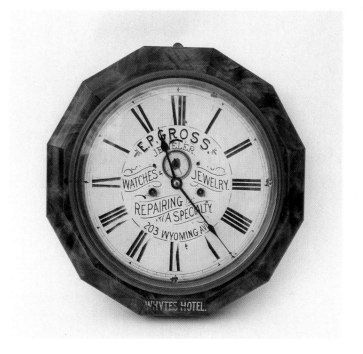

It appears that this E.P.G. Ross Jeweler clock may have been *"custom"* painted. This was a common practice, as it allowed even small-time businesses to get their fair share of the advertising market. This twelve-sided example measures 16" in diameter. *Courtesy of Jerry and Millie Maltz.*

Most everything was tried at some point to bring customers to the product. Why not put the clock right on the display rack? This Reichardt's Chocolates dispenser not only gave you the time, but an easy opportunity to buy their confection as well. It dates to around 1935, and measures 8" x 17" overall. *Courtesy of Jerry and Millie Maltz.*

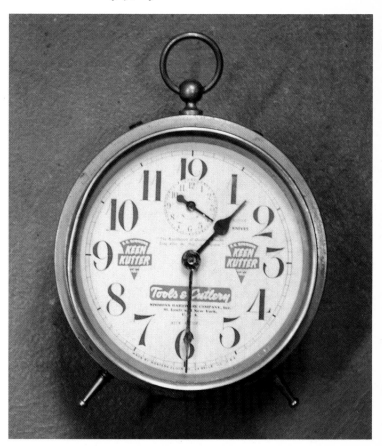

The Lux Clock Manufacturing Company of Waterbury, Connecticut, was the supplier of the movement used in the Reichardt's Chocolates dispenser. However, it's unlikely that they manufactured the wooden display stand as well. As can be observed by the close-up of the label on the back side, the unit was shipped complete with contents to the retailer. *Courtesy of Jerry and Millie Maltz.*

Keen Kutter had this *"Big Ben"* style alarm clock made for them in the 1920s. There are several different companies that also used these clocks for their advertising, and they all had paper label dials. *Private collection.*

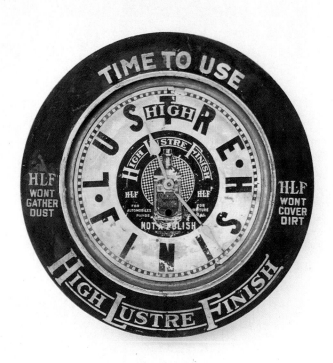

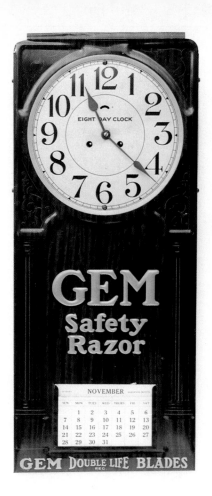

High Lustre Finish was the focus of this circa 1920s clock built by Sessions Clock Company. It measures 18" in diameter. *Courtesy of Jerry and Millie Maltz.*

This Gem Safety Razor advertisement is a combination clock and calendar. Its construction is of embossed sheet metal, and it dates to around 1915. It measures 12.5" x 29.5". *Courtesy of Jerry and Millie Maltz.*

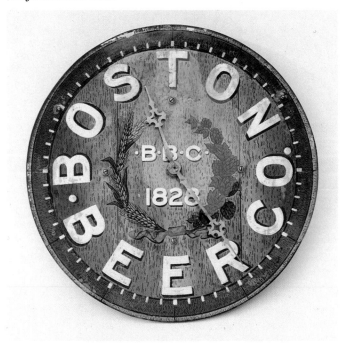

The Pepsi-Cola Company had a limited number of these "Ballerina" clocks made in the 1930s. The girl at the bottom spun around in a circle. It measures a scant 4" x 6", and was manufactured in Germany by The Rensie Watch Company. *Courtesy of John H. Johnson.*

The entire dial of this outstanding Boston Beer Company clock is made of heavy plate glass. Its raw wood effect is the result of being reverse painted. It was manufactured around 1890 by the Waterbury Clock Company of Waterbury, Connecticut, and measures 14" in diameter. *Courtesy of Jerry and Millie Maltz.*

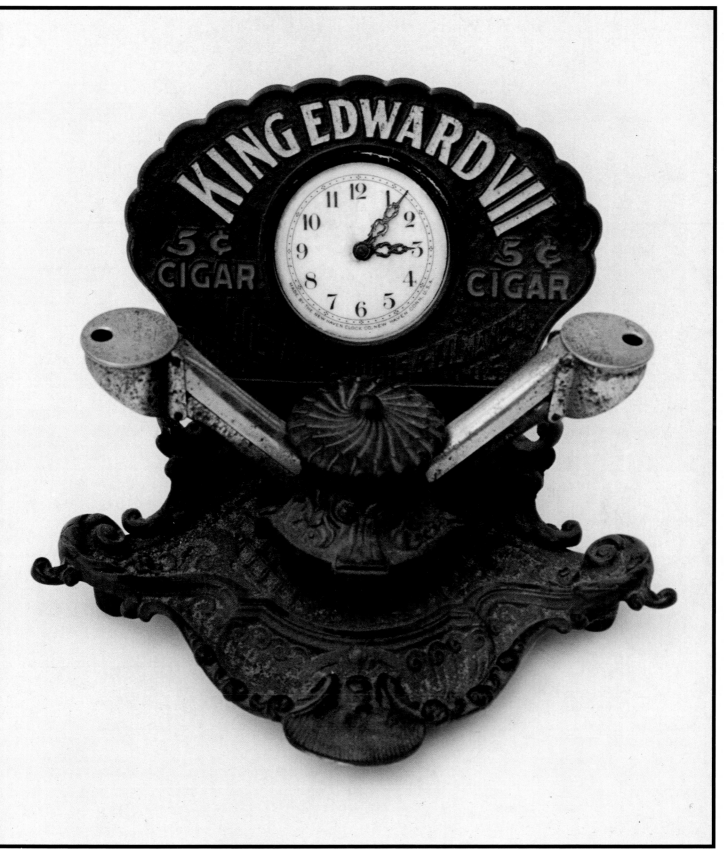

This fantastic King Edward VII double cigar cutter was
manufactured in the 1880s. It is constructed of cast iron, and,
as the photograph suggests, is heavily embossed. It measures
10" x 8", and was produced by the Brunhoff Manufacturing
Company of Cincinnati, Ohio. *Courtesy of Jerry and Millie Maltz.*

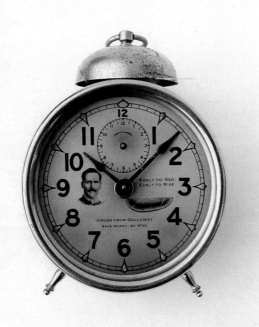

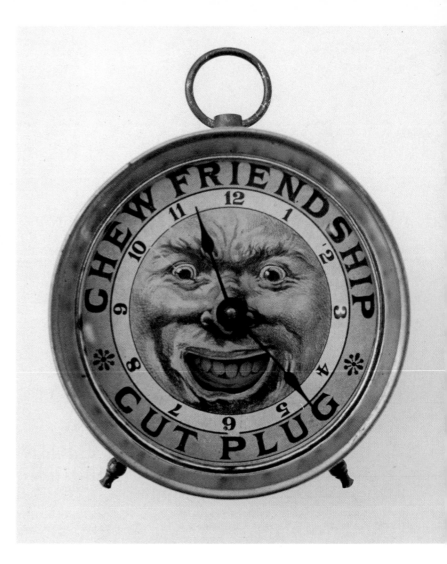

This circa 1905 alarm clock has a man's picture on the left, and a drawing of a watermelon on the right. The poem reads: *Early to bed, Early to rise; Order from Galloway, Save money, be wise.* We can only surmise that Galloway was a fruit and vegetable dealer. It measures 4" x 5.5". *Courtesy of Jerry and Millie Maltz.*

Friendship Cut Plug was the company behind this bizarre looking desk clock. Its movement included a mechanism that enabled the *"mouth"* of the man to *"chew"* tobacco. It measures 4" x 5.5". *Courtesy of Jerry and Millie Maltz.*

Old Mr. Boston produced this timely trio in the 1920s era. The large clock in the center is constructed of metal, measures 10" x 21.5", and is fairly common. The two smaller clocks are made of solid wood, and are much scarcer. All were manufactured by the Gilbert Clock Company of Winsted, Connecticut. *Courtesy of Jerry and Millie Maltz.*

Chapter 3
Neon Clocks

Around 1930, the advertising world went neon. This new lighting system gave even the most mundane advertisement a bright, eye-catching look. Although the majority of neon advertising was manufactured for large outdoor displays, thousands of clocks were built with a neon message.

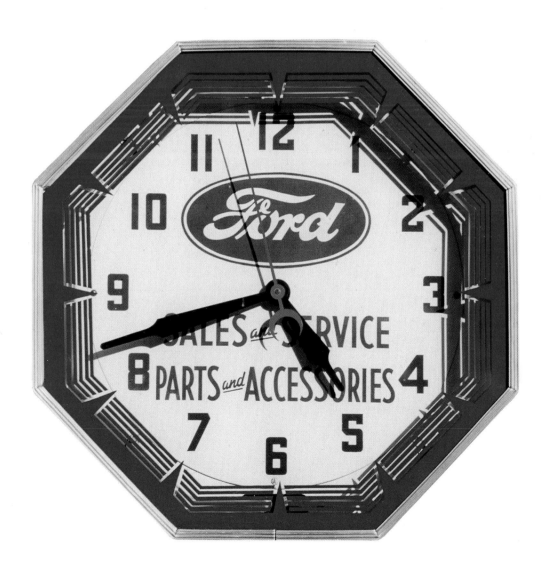

This Ford Sales and Service advertising clock is typical of the thousands of 18" eight-sided neon clocks built between 1930 and 1950. The neon tube follows the perimeter of the clock behind the green silk-screened glass. Neon Products Incorporated of Lima, Ohio, was the manufacturer, and it dates to around 1940. *Courtesy of Gene Sonnen.*

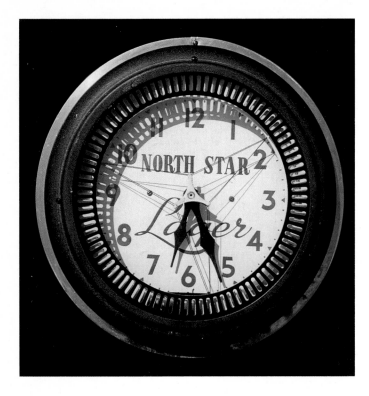

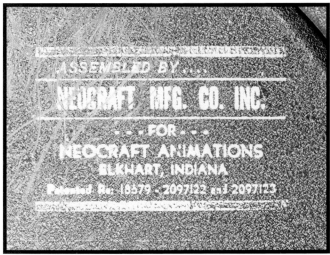

One of the items that are unique to advertising clocks is the use of a rotating frame that was placed around the outside of the dial and would take the place of a second hand. These are referred to as *"spinners."* The neon tube was between the dial and the spinner, and the spinner was under a silk-screened outer glass. As the spinner moved, it would create a dazzling effect of pulsating light that was sure to get attention. This North Star Lager clock dates to the 1940s, and measures 15" in diameter. *Courtesy of Darryl Tilden.*

Here's a shot of the manufacturer's stamp on the back side of the North Star Lager clock. Neocraft produced many spinner-type clocks through the years, which they termed *"animated."* *Courtesy of Darryl Tilden.*

Old Style Lager made this easy-to-spot neon advertising clock in the 1930s. If you follow the neon tube, you'll notice that it continues around the outside perimeter of the clock. To top it all off, the outstanding graphics on the dial were back-lit as well! It measures 27" x 11", and was manufactured by Panellit Displays Incorporated, Chicago, Illinois. *Courtesy of Darryl Tilden.*

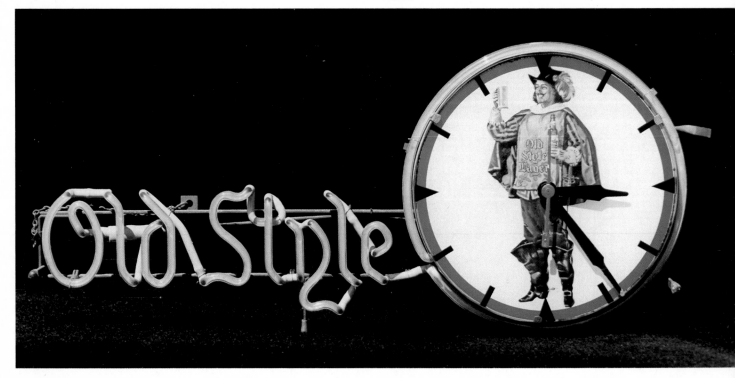

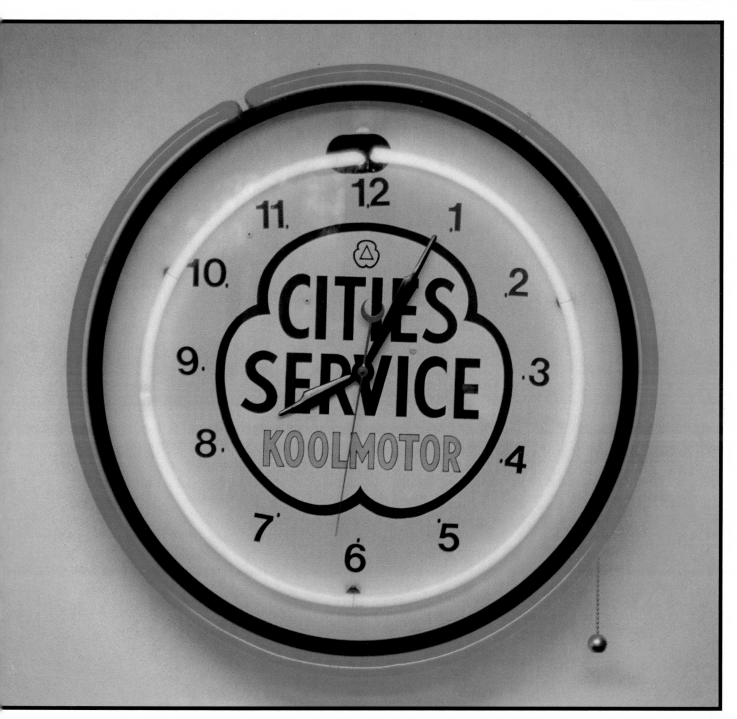

Two different color neon tubes were employed in this outstanding Cities Service KoolMotor clock. It measures 21" in diameter, and dates to the 1940s. *Courtesy of Nick Conner.*

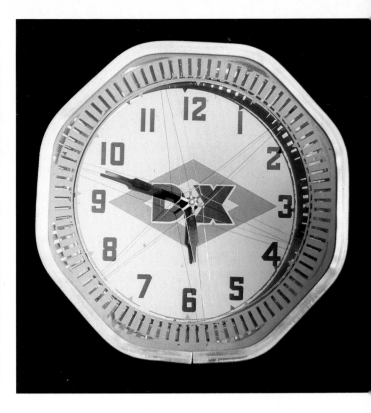

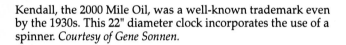

Kendall, the 2000 Mile Oil, was a well-known trademark even by the 1930s. This 22" diameter clock incorporates the use of a spinner. *Courtesy of Gene Sonnen.*

This DX Gasoline clock had an unusual wide aluminum frame. It measures 18" in diameter, and dates to the 1930s. *Courtesy of Gene Sonnen.*

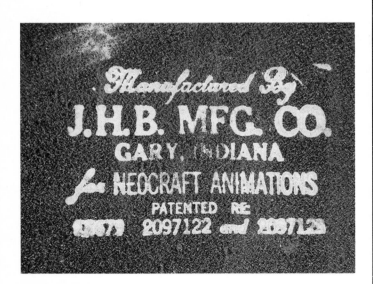

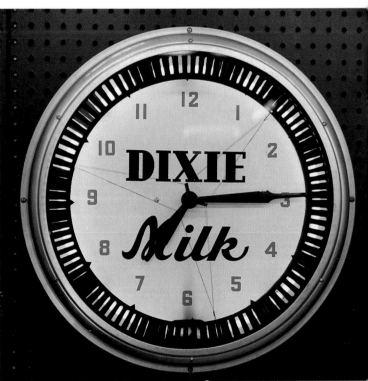

Here's a photo of the manufacturer's stamp on the back side of the Kendall clock. Although J.H.B. Manufacturing were the final builders, Neocraft Animations still produced the spinner mechanism, and held the patents. *Courtesy of Gene Sonnen.*

Even plain-looking graphics could be noticed with the addition of a spinner. This Dixie Milk clock still gets plenty of attention. It measures approximately 20" in diameter, and dates from the 1940s. *Courtesy of W.K. Richards at Oakwood Antique Mall.*

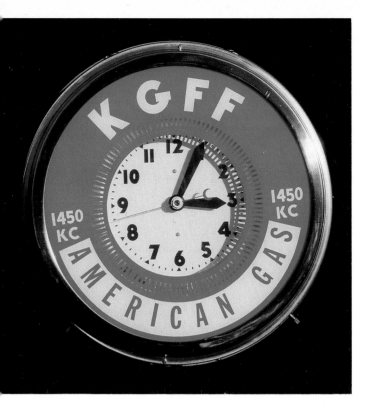

KGFF Radio 1450 had this unusual small-dial neon clock made for them in the 1950s. It incorporated a spinner with a neon tube around the dial, but also had a second tube to back light the rest of the outer glass. It measures 21" in diameter. *Courtesy of Gene Sonnen.*

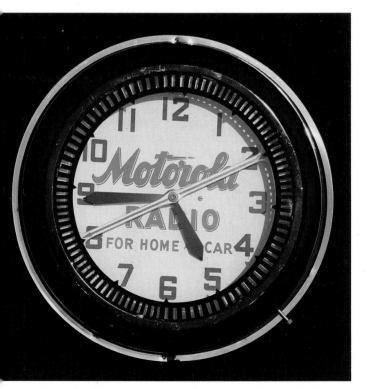

This super Motorola Radio clock utilizes an unusual support system for its spinner, as it functions as a second hand as well. The manufacturer was Kolux of Kokomo, Indiana. It measures 22" in diameter, and dates to the 1940s. *Courtesy of Olde Orchard Antique Mall.*

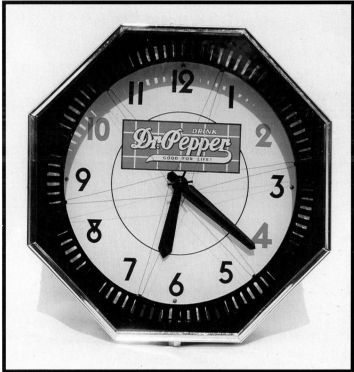

Neon Products of Lima, Ohio, were the producers of this super eight-sided Dr. Pepper clock with spinner. Notice that their popular 10-2-4 slogan was reflected in the red painted numbers on the dial. It measures 18" in diameter, and was manufactured in the 1940s. *Author's collection.*

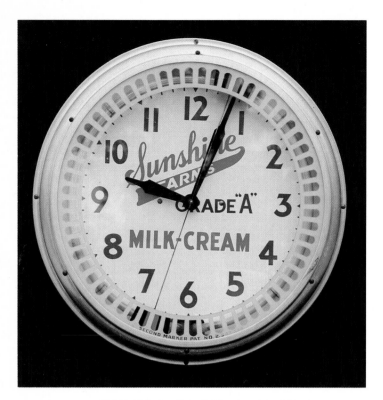

Sunshine Farms was the topic on this beautiful neon advertising clock. The second hand functions as a spinner, but only in an area of about 2" on both ends of the hand. This patented feature was called a *"double ended"* second hand. The clock was manufactured by one of the larger producers of later-era advertising clocks, the Swihart Products Co., of Elwood, Indiana. This one measures approximately 20" in diameter, and dates to around 1950. *Courtesy of Bruce Stevens and Sons.*

To those who collect Pepsi-Cola related collectibles, few items could top this! What an outstanding example of style and a beautiful product advertisement as well. Neon tubing borders the marquee at the bottom, which was done with reverse painted glass. The clock dial itself is also reverse painted. Both the dial and marquee are back-lit to create a fabulous display of graphics and light. It measures 24" x 24", and dates to the 1930s. *Courtesy of Mike Johnson.*

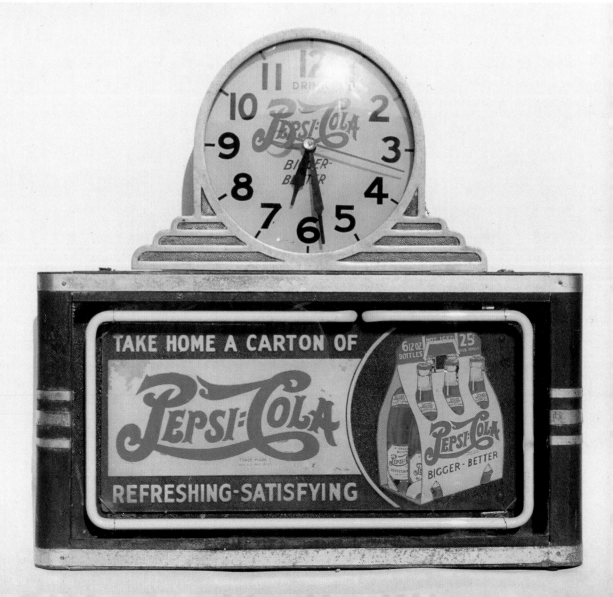

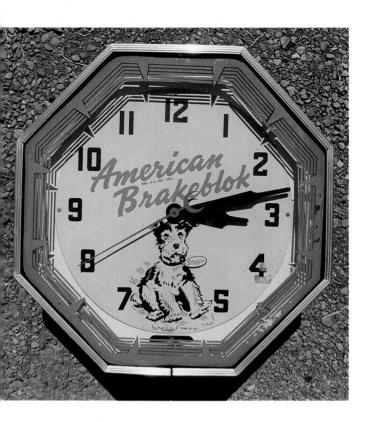

American Brakeblok gave an otherwise so-so looking clock some pizazz with the inclusion of their trademark dog, *"Stopper."* Notice that the dial is on a round piece of sheet metal. This no doubt made it easy for the manufacturer to produce a multitude of advertising clocks with a minimum of expense. It measures 18" in diameter, and dates to the 1940s. *Courtesy of Betty Case.*

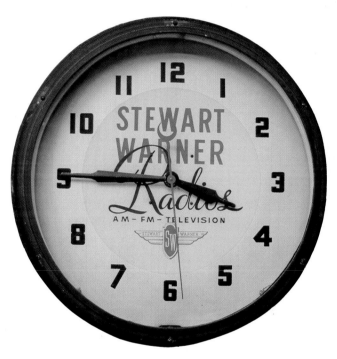

Stewart Warner Radios had this 1940s era clock made for them when radio was still big. Although television was in its infancy, it still managed to find its way into part of the graphics on this 22" diameter clock. *Courtesy of Canal Park Antique Centre.*

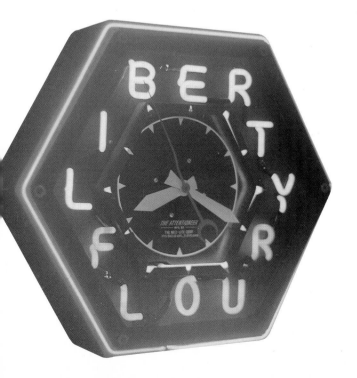

Almost anyone would be impressed by the creative use of neon found on this six-sided Liberty Flour clock. It was manufactured by the Neo-Lite Company, and was given the appropriate trade name *"The Attentioneer."* Not only were the words *"Liberty Flour"* done in two colors of neon, but a tube ran around the clock dial as well as the outside perimeter. It measures approximately 26" in diameter and dates from the 1930s. *Courtesy of Darcy Salbert at Neon Images.*

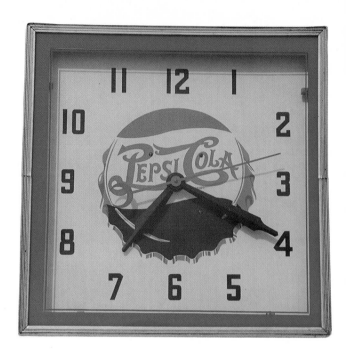

Pepsi-Cola utilized their *"bottle cap"* logo on many advertisements. This 15" x 15.5" model was built by the Lackner Clock Company in the 1940s. *Courtesy of John H. Johnson.*

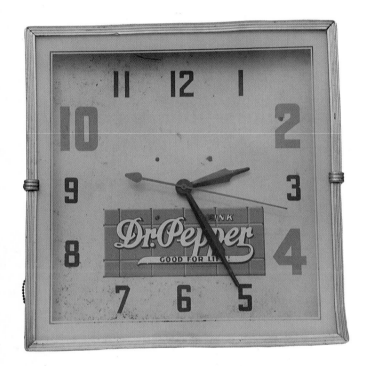

Though the years, Dr. Pepper had the opportunity to try many different types of advertising on clocks. This circa 1950 metal dial example has a single white neon tube around its border, and measures 15.5" x 15.5". *Courtesy of John H. Johnson.*

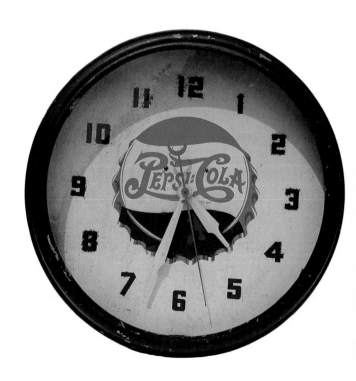

Here's another variation on the Pepsi theme. It measures 20" in diameter, and has a single white neon tube around its perimeter. It dates from the 1930s era. *Courtesy of John H. Johnson.*

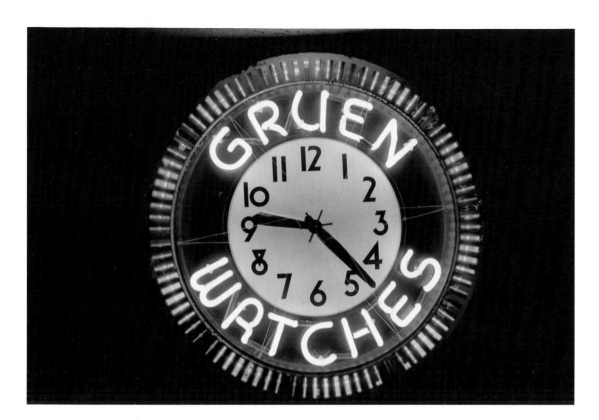

This night-time shot of a neon Gruen Watches clock should give you an idea as to why spinner mechanisms became so popular. This particular clock also features a back-lit dial. It measures approximately 22" in diameter, and dates to the 1930s. *Courtesy of Ken Baisa at Ken-Glo Clocks.*

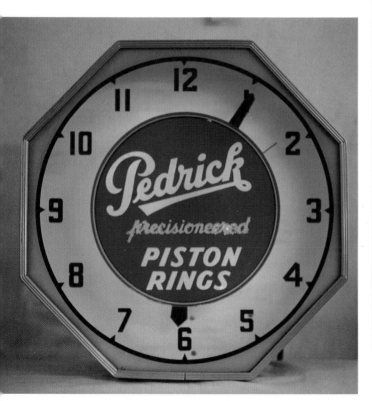

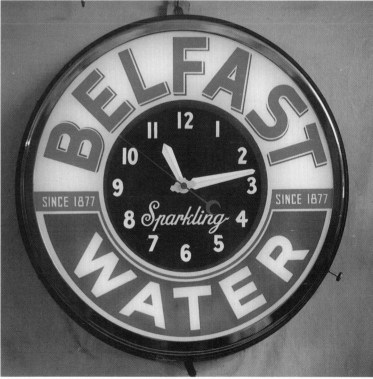

Blue neon gave this Pedrick Piston Rings clock an eerie glow. It measures approximately 18" in diameter and dates from the 1940s era. *Courtesy of Ken Baisa at Ken-Glo Clocks.*

The use of neon behind its silk-screened dial made this Belfast Water clock come alive. Unfortunately, many of the old original dials have succumbed to the elements, mostly due to poor silk-screening techniques. This beautiful example is definitely the exception! Measures approximately 20" in diameter, and dates to the 1940s. *Courtesy of Ken Baisa at Ken-Glo Clocks.*

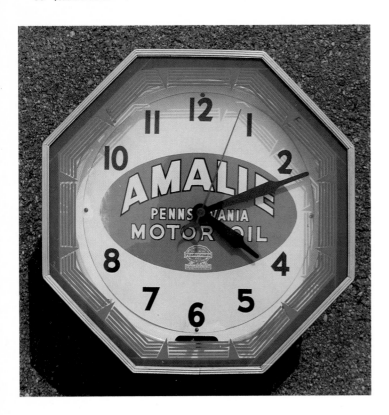

A single white neon tube was used in this circa 1940s Amalie advertising clock. It measures 18" in diameter. *Private collection.*

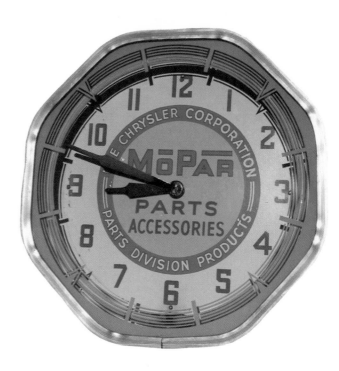

This Mopar Parts and Accessories clock had a wide aluminum border. It measures 18" in diameter, and dates to the 1940s. *Courtesy of Frank J. Liska.*

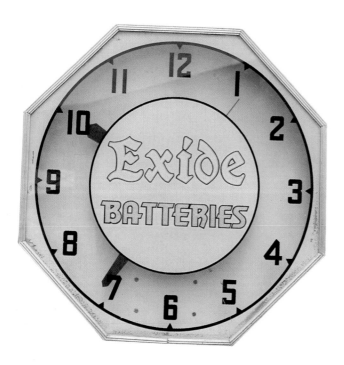

Exide Batteries used this 18" diameter clock in the 1940s era. *Courtesy of Gary Parker.*

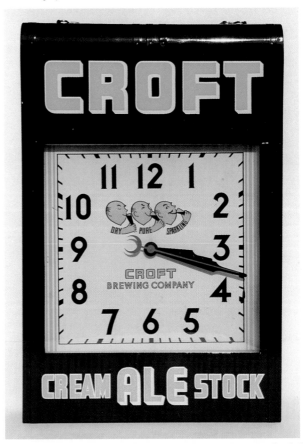

Croft Brewing Company of Boston, Massachusetts, had this neat-looking clock made around 1935. It measures 18" x 27". *Courtesy of Dick and Kathy Purvis.*

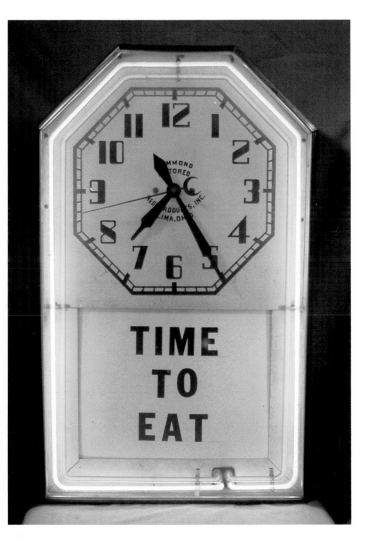

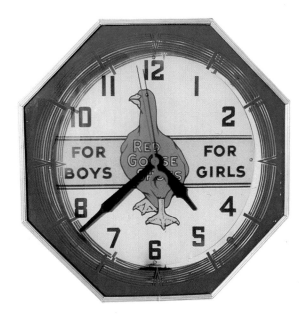

Few American trademarks are as beloved as the one used by Red Goose Shoes. The large graphics found on this circa 1940s clock offers plenty of eye-appeal. It measures 18" in diameter. *Courtesy of Jim Humphrey.*

Neon Products of Lima, Ohio, produced this *"upright"* style clock in the 1930s. It featured an interchangeable cardboard back for the advertising slogan and in this case, one of Bill Brown's personal favorites! Notice that the dial says *"Hammond Motored."* The Hammond Clock Company produced impulse-driven as well as conventional electro-magnetic motors in the 1930s era, and using this technology, would later become one of the world's great names in electric organs. *Courtesy of Ken Baisa at Ken-Glo Clocks.*

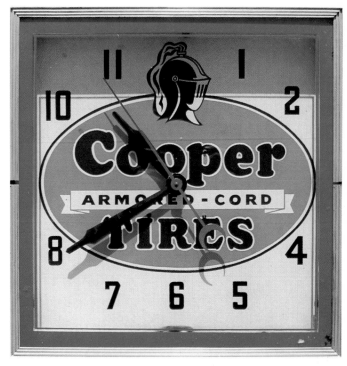

Cooper Tires used this large logo clock in the era around 1950. It had a single white neon tube around the dial. *Courtesy of Darcy Salbert at Neon Images.*

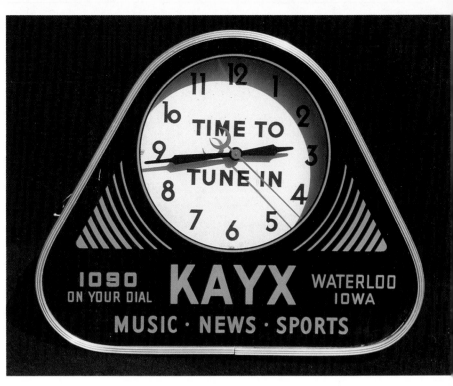

KAYX had this great-looking clock made for them by an unknown manufacturer in the 1940s. It measures 23" x 19". *Courtesy of Bob Nelson.*

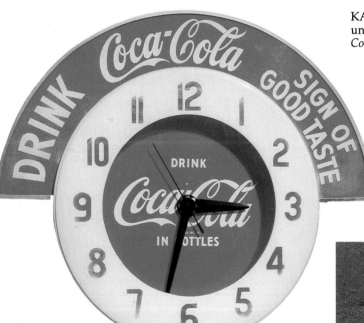

This large outside-type Coca-Cola clock was designed to be used on the sides of stores and restaurants. It measures 26" in diameter around the dial, and the marquee would add about an additional 10". These popular clocks were manufactured by the Cleveland Electric Neon Clock Company. Although they are from the 1950s era, some can still be found on buildings today as a reminder of days gone by. *Courtesy of Bob Nelson.*

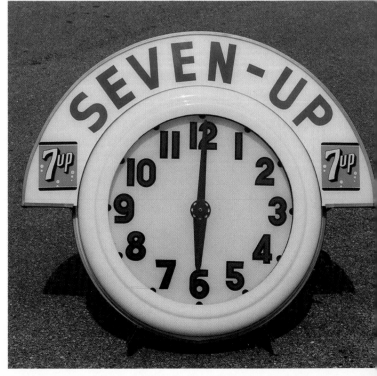

Here's another example of the Cleveland Clock Company's handiwork. The measurements and age are the same as the Coca-Cola clock above. *Private collection.*

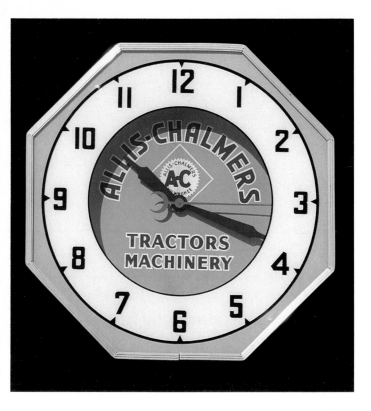

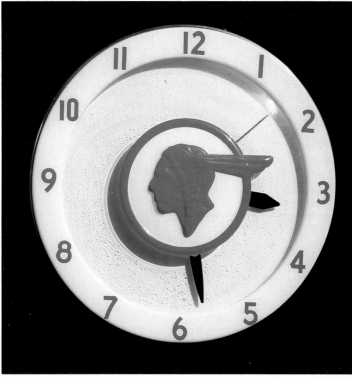

This Allis-Chalmers clock was manufactured by Neon Products Company of Lima, Ohio. It measures 18" in diameter, and dates from the 1940s. *Courtesy of Darryl Tilden.*

Chief Pontiac was the center image on this circa 1940s clock that had an all-plastic front. Two neon tubes were used to light the dial's numbers. It measures 18" in diameter and was produced by Prestyle Manufacturing Company of Detroit, Michigan. *Courtesy of Bob Nelson.*

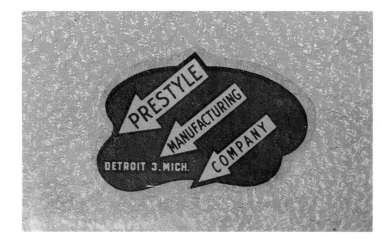

A close-up look at the Chief Pontiac clock's manufacturer's label. *Courtesy of Bob Nelson.*

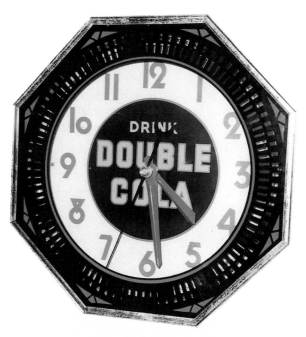

Deco style numbers help date this Double Cola clock to the 1930s. It was manufactured by Neon Products and measures 18" in diameter. *Courtesy of Charles Kleeberg.*

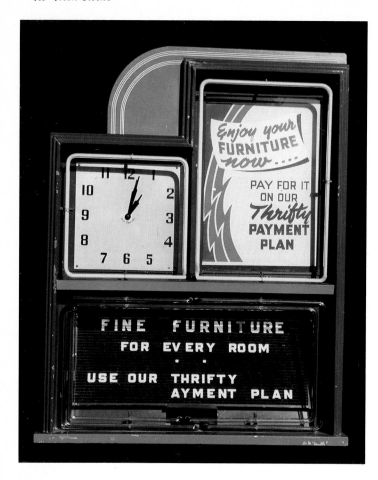

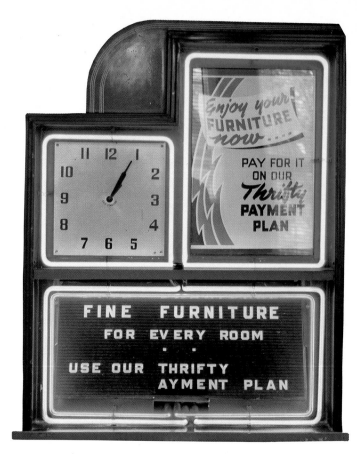

This *"generic"* counter-top display could be used not only in a furniture store, but most any other business as well. The clock and the two marquees were trimmed in neon. The sign in the upper right could be interchanged as required. The bottom marquee featured a board with interchangeable lettering. It measures 26" x 33" and dates from the 1940s. *Courtesy of Bob Nelson.*

A night-time view. *Courtesy of Bob Nelson.*

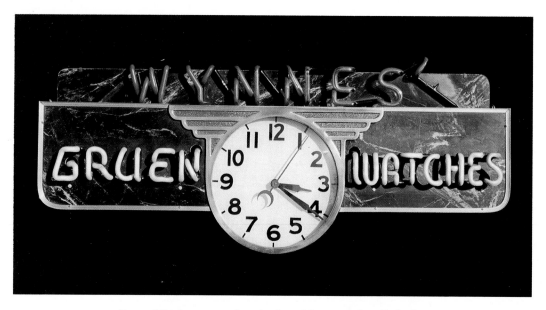

Gruen Watches were advertised on this unusual wall clock. Wynnes' was obviously the local merchant. The clock dial was back-lit as well. It measures 36" x 13.5", and dates to the 1930s. *Courtesy of Bob Nelson.*

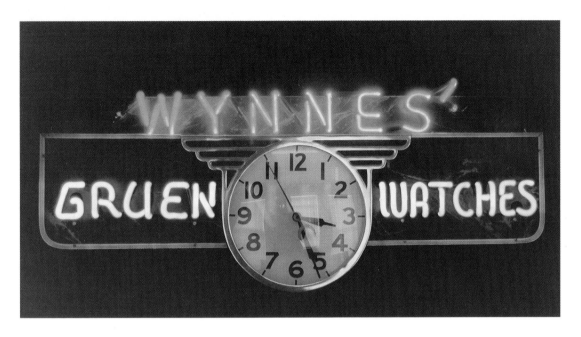

A night-time view. *Courtesy of Bob Nelson.*

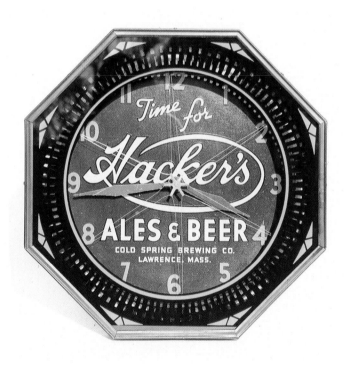

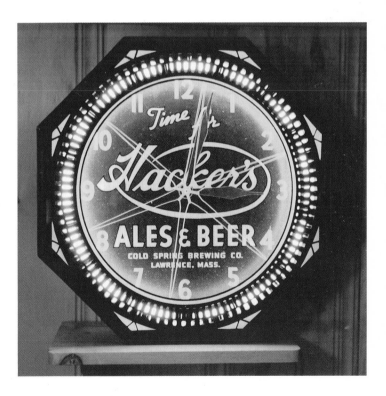

This super Hacker's Ales and Beer neon was produced in the era around 1940. It measures 18" in diameter. *Courtesy of Dick and Kathy Purvis.*

Night lighting is an essential form of promotion, and is another reason that neon became such a powerful selling point in the advertising clock market. *Courtesy of Dick and Kathy Purvis.*

Chapter 4
Back-Lit Dial Clocks

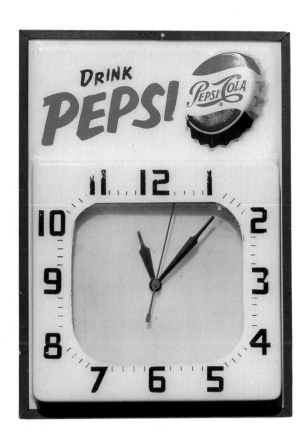

The period of 1940 to 1965 saw tens of thousands of advertising clocks being produced in America. The vast majority of these employed silk-screened dials that could be lighted from behind. The sheer numbers of these that were manufactured as well as their relatively recent vintage have given the collecting world a cornucopia of collectible clocks.

Reliance Advertising Company of Chicago, Illinois, was the manufacturer of this plastic-faced Pepsi-Cola clock from the 1950s. It measures 14" x 19.5". *Courtesy of Roger Blad.*

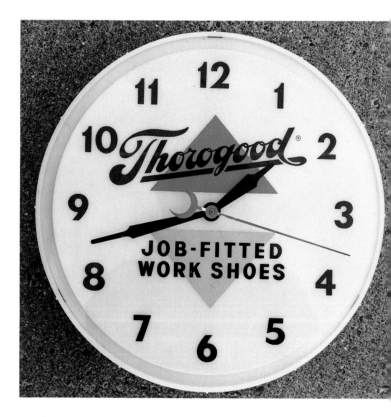

Thorogood Shoes used this all-plastic clock in the 1960s. It measures approximately 16" in diameter. *Courtesy of Superior Antique Depot.*

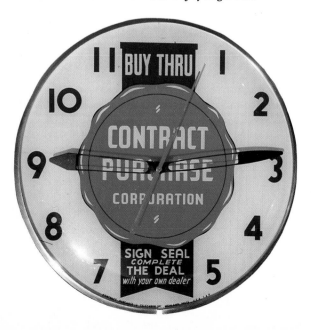

Contract Purchase Corporation used this clock in the 1950s. It measures 14.5" in diameter and was made by Telechron Incorporated of Ashland, Massachusetts. *Courtesy of Jim Humphrey.*

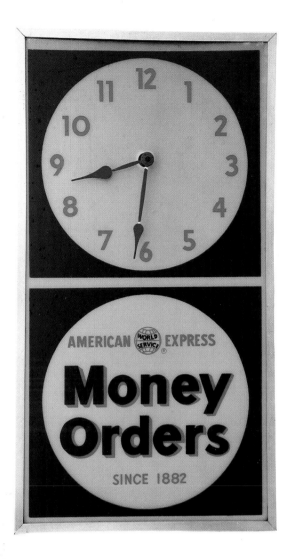

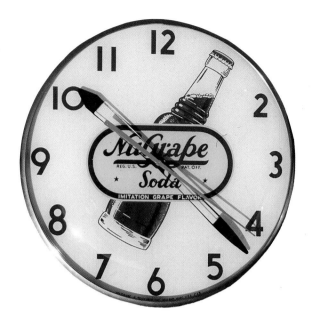

Telechron was the manufacturer of this 14.5" NuGrape clock. Even if you didn't know clocks, the circa 1950s bottle helps date this one. *Courtesy of Jim Humphrey.*

This American Express Money Orders clock dates from the 1960s. It measures approximately 13" x 26". *Courtesy of Donna and Jim Hillstrom.*

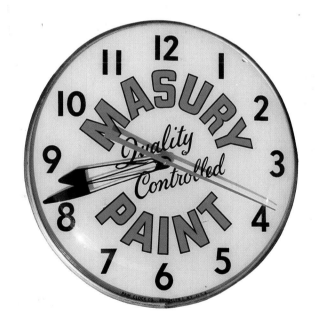

Masury Paint made sure their name got more than a casual look on this 1950s clock built by Pam Clock Company. *Courtesy of Jim Humphrey.*

One of the largest ginger ale producers in America is Vernors. A good part of this success may be due to the many beautiful advertising clocks that they had manufactured through the years. This 22" diameter example features their well-known *"gnome"* trademark. Unfortunately, most of these clocks were made with a type of silk screening that easily deteriorated in time, and the example shown here is exceptional. It dates from the era around 1960, and was manufactured by Pam Clock Co. of New Rochelle, New York. *Courtesy of Jim Humphrey.*

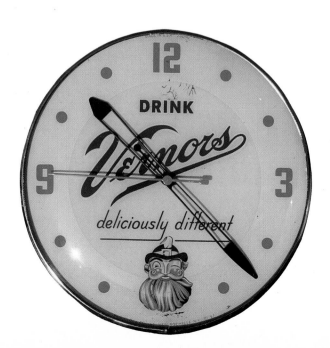

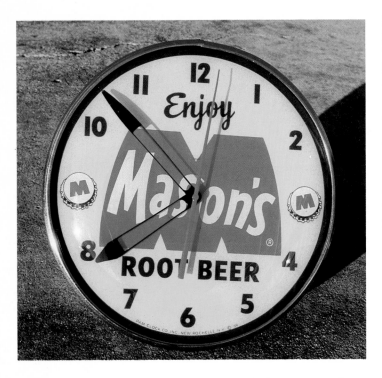

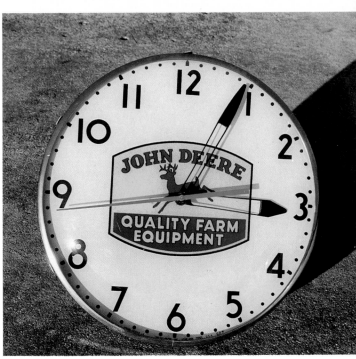

This 14.5" diameter Mason's Root Beer clock dates to around 1960. *Courtesy of Jim Humphrey.*

Nothing runs like a Deere, with the possible exception of a clock built by Telechron Incorporated. This 14.5" diameter model is a beauty. *Courtesy of Jim Humphrey.*

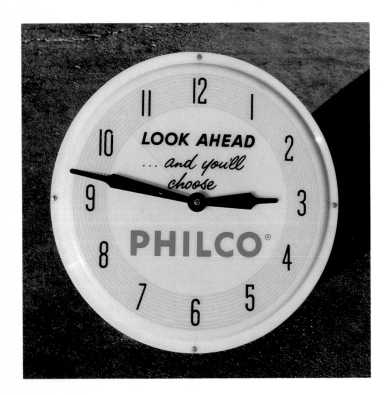

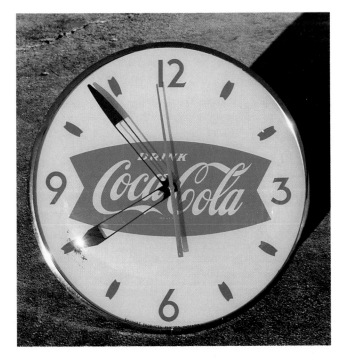

All-plastic construction was the choice for this Philco Clock of the 1960s. *Courtesy of Jim Humphrey.*

The *"Fishtail"* logo was used by Coca-Cola for many years, found mostly on advertising in the 1950s. This textbook example of that famous logo is not only featured as this clock's focal point, but its silhouette can be seen in place of numbers going around the dial. Build by Swihart Products of Elwood, Indiana. *Courtesy of Jim Humphrey.*

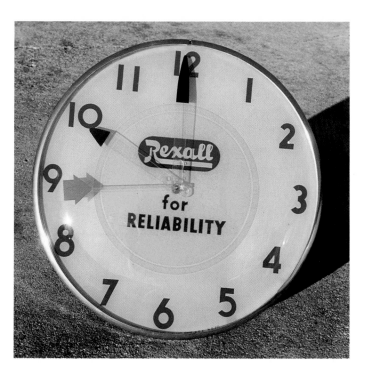

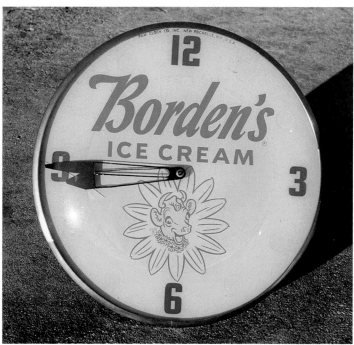

Telechron produced some of their clocks with clear plastic hands. This novelty never seems to have caught on though, as their production was limited. The obvious advantage can be seen here in this 1950s Rexall clock. *Courtesy of Jim Humphrey.*

Borden's was a large producer of dairy products in the 1950s. This bright-colored clock features their trademark, *"Elsie"* the cow. If you look closely, Pam Clock Company put their stamp around the top edge. This is unusual, and the reason for it remains a mystery. *Courtesy of Jim Humphrey.*

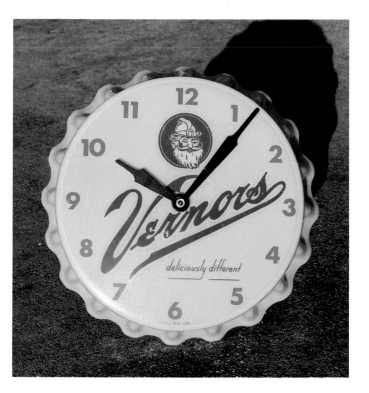

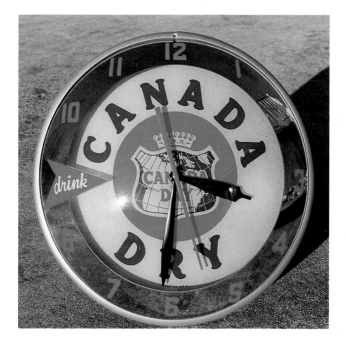

This all-plastic Vernors clock is formed into the shape of a bottle cap. It measures approximately 11" in diameter, and dates to the 1960s. *Courtesy of Jim Humphrey.*

This outstanding Canada Dry clock was manufactured by the Advertising Products Company of Cincinnati, Ohio. It has an inner dial with the featured advertising, and the outer *"crystal"* has the numbers. These desirable clocks have been given the catch name *"Double Bubble"* by collectors. It dates from around 1960, and measures approximately 15" in diameter. *Courtesy of Jim Humphrey.*

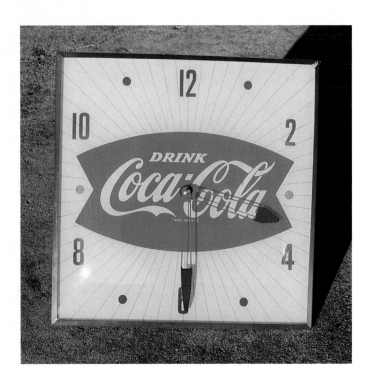

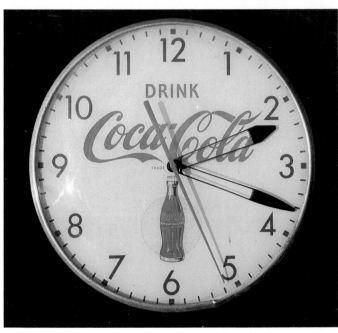

Here's a square back-lit dial clock with Coca-Cola's famous "Fishtail" logo. It measures approximately 16" square, and dates to the 1960s era. *Courtesy of Jim Humphrey.*

Coca-Cola added this clock to its endless list of advertisements around 1950. It was manufactured by Pam Clock Company. *Courtesy of Bernie and Annette Nagel.*

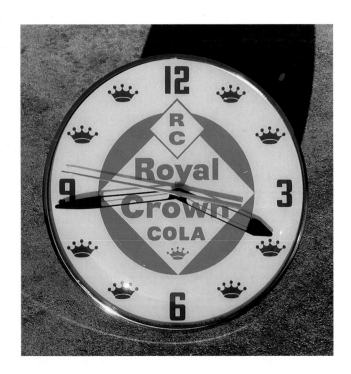

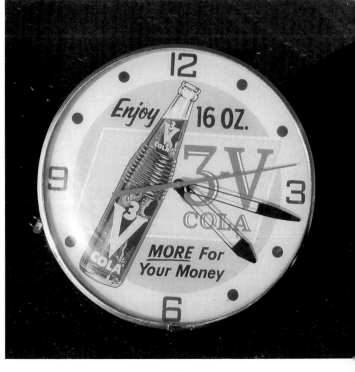

Pam Clock Company produced this Royal Crown clock in the late 1950s. *Courtesy of Jim Humphrey.*

3-V Cola was a relatively short-lived product. But not so short as to prevent them from advertising their product on this circa 1950s clock manufactured by Pam Clock Company. *Courtesy of Bernie and Annette Nagel.*

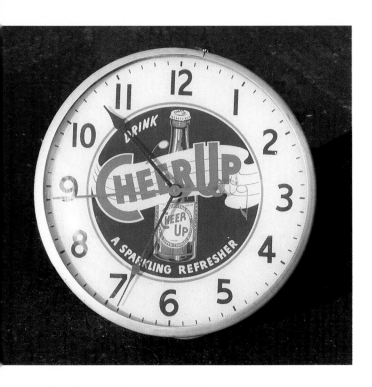

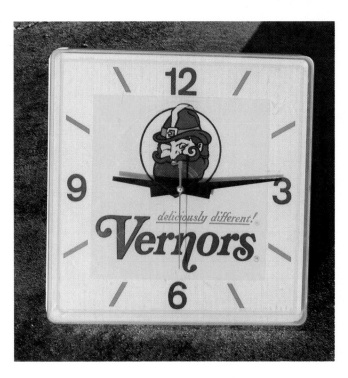

Swihart Products Company was the manufacturer of this 1950s clock for Cheer Up. *Courtesy of Bernie and Annette Nagel.*

All-plastic construction was the new thing in this circa 1960s Vernors clock. The crystal was made of clear acrylic as well. It measures approximately 16" square. *Courtesy of Jim Humphrey.*

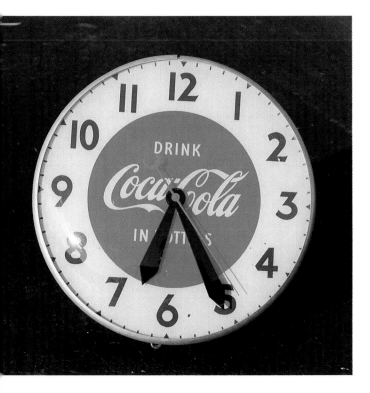

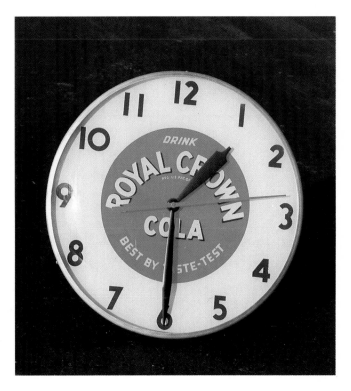

Here's one more from a long list of Coca-Cola clocks made through the years. This one was a product of Pam Clock Company. *Courtesy of Bernie and Annette Nagel.*

This Royal Crown clock was made by Telechron in the 1950s. *Courtesy of Bernie and Annette Nagel.*

This outstanding representation of the clock maker's silk-screening art dates to the 1950s, and was produced by Telechron. Although this particular model has metal hands, some were made with the clear acrylic ones. It measures 14.5" in diameter. *Courtesy of Bernie and Annette Nagel.*

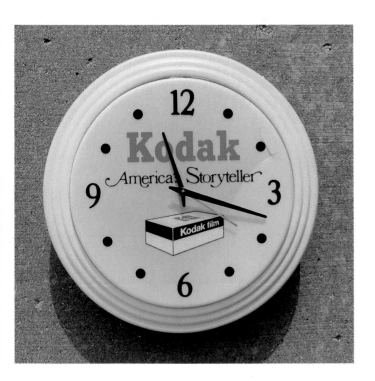

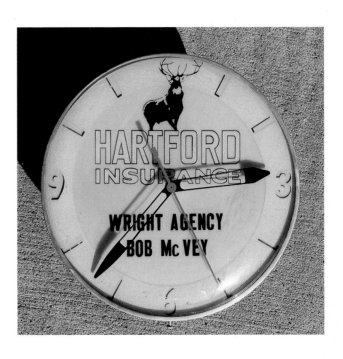

Kodak had this all-plastic-faced clock made for them in the 1970s. As large as the Kodak Corporation is, their clocks are relatively scarce. This one measures approximately 20" in diameter. *Courtesy of John R. Heafield at PhotoFast.*

The local agent's names were placed prominently on this Hartford Insurance clock. *Courtesy of Dave Higgs.*

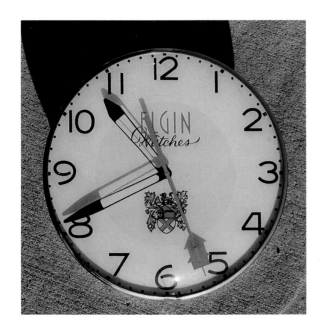

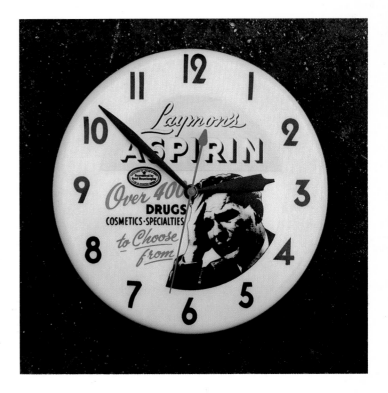

Elgin Watches used this clock in the 1960s era. It measures 14.5" in diameter. *Courtesy of Dave Higgs.*

This unusual Laymon's Aspirin clock had a metal backing and an all-plastic case. It came alive when viewed at night. It measures 16" in diameter. Although it uses incandescent bulbs, it was manufactured by Neon Products, Inc., of Lima, Ohio. *Author's collection.*

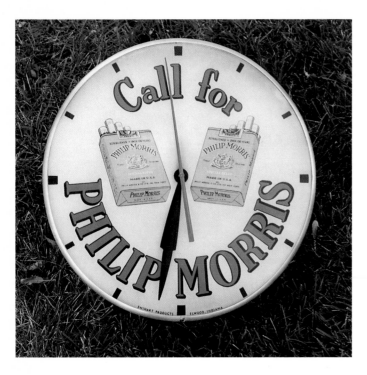

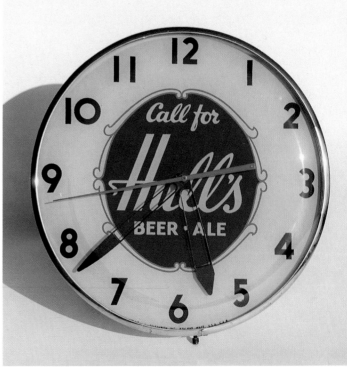

Swihart Products Company was the manufacturer of this beautiful Philip Morris clock. It dates from the era around 1945, and measures approximately 15" in diameter. *Author's collection.*

Telechron produced this Hull's 14.5" diameter clock around 1960. *Courtesy of Dick and Kathy Purvis.*

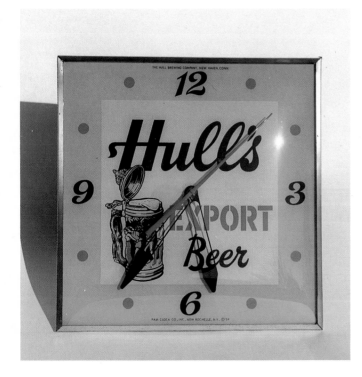

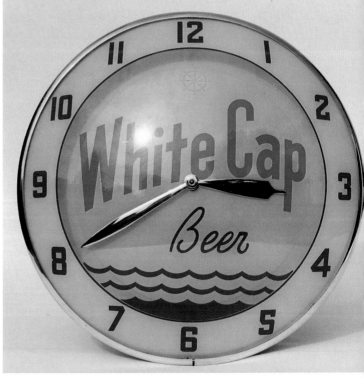

Hull's Export Beer used this square clock around 1960. It was manufactured by Pam Clock company. *Courtesy of Dick and Kathy Purvis.*

White Cap Beer was made by a brewery in Manitowoc, Wisconsin. This *"Double Bubble"* style clock was a product of the Advertising Products Company of Cincinnati, Ohio. *Author's collection.*

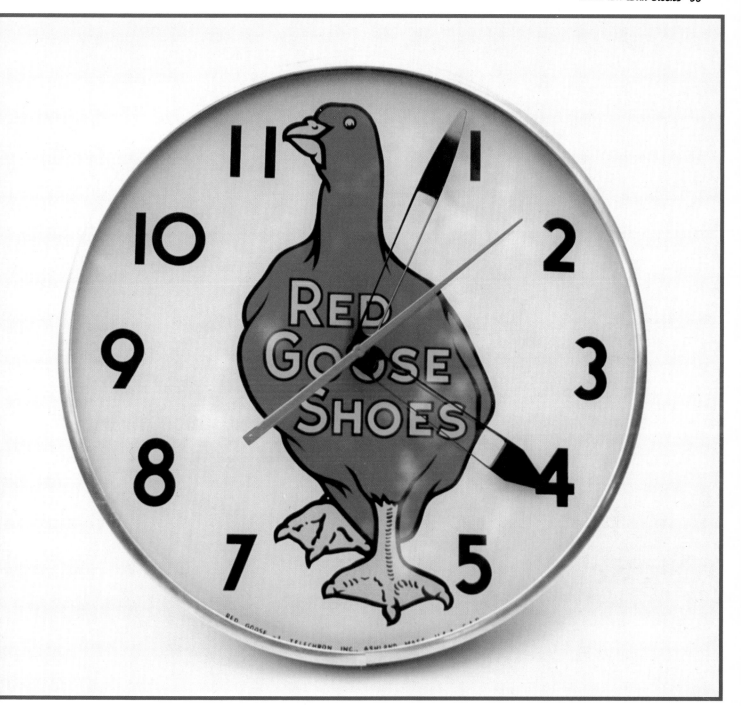

Telechron produced this super Red Goose Shoes clock in the 1950s. The large logo puts this one on collectors' *"most-wanted"* lists. It measures 14.5". *Author's collection.*

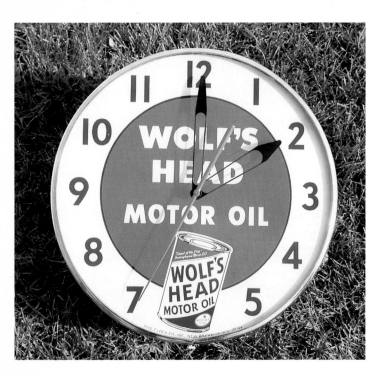

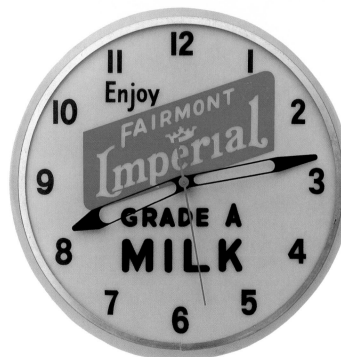

Wolf's Head Motor Oil had a variety of clocks produced through the years. This one was made by Pam Clock Company, and features an image of a Wolf's Head Motor Oil can. *Author's collection.*

Dualite Displays of Cincinnati, Ohio, was the manufacturer of this Fairmont Imperial Grade A Milk clock. Dualite clocks featured one-piece plastic-body construction, with a crystal that was retained by an aluminum ring. These clocks were capable of long service, provided someone unfamiliar with the properties of plastics didn't replace its 15 watt light bulbs with 75 watt models. It measures approximately 16" in diameter, and dates from the 1950s. *Courtesy of Bill and Jane Wrenn.*

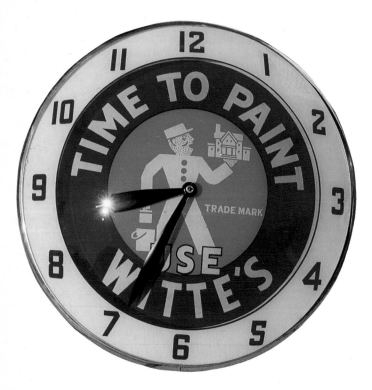

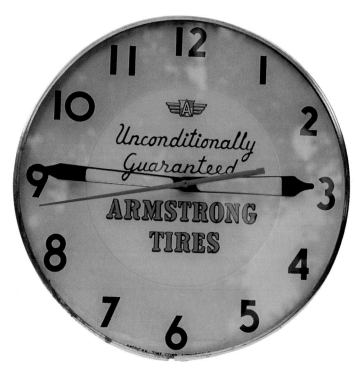

Witte's Time To Paint *"Double Bubble"* style clock. It dates to the 1950s. *Author's collection.*

Armstrong Tires used this clock in the 1950s. The stamping at the bottom says: *"American Time Corporation." Courtesy of Bill and Jane Wrenn.*

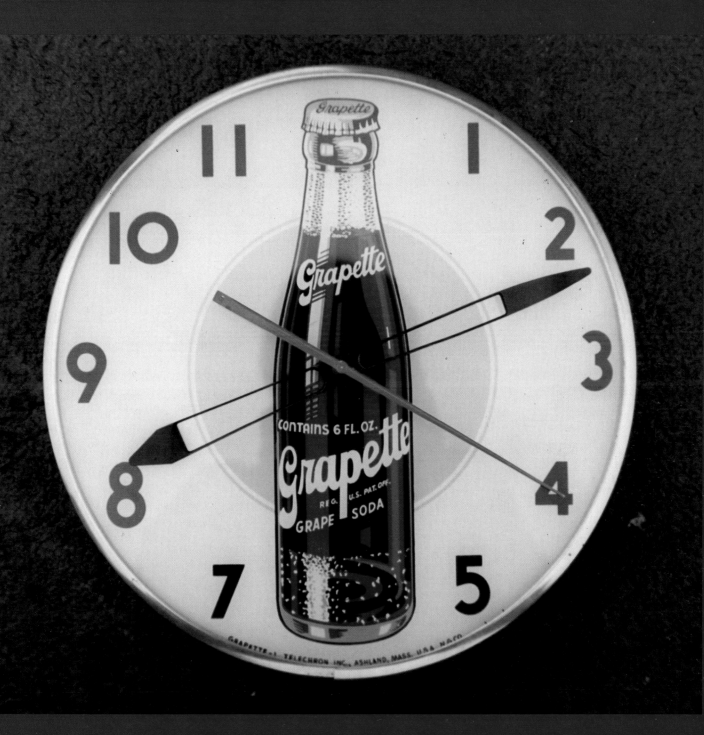

Having this bottle of Grapette pictured large on the dial gave
the needed visual impact. Telechron was the manufacturer of
this beautiful 1950s clock. *Courtesy of Carl Barrow.*

Nesbitt's advertising could be found on a variety of clocks through the years. This model was manufactured by Telechron in the 1950s. *Courtesy of Bill and Jane Wrenn.*

Advertising clocks featuring Telechron are scarce. For all the thousands of advertising clocks produced by Telechron through the years, few have surfaced headlining their name. *Author's collection.*

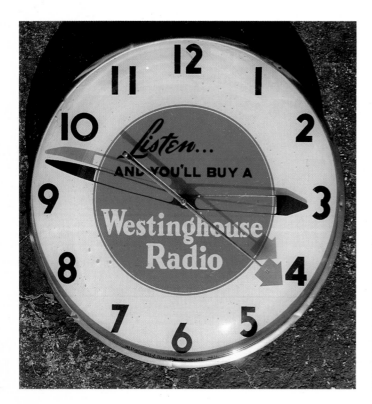

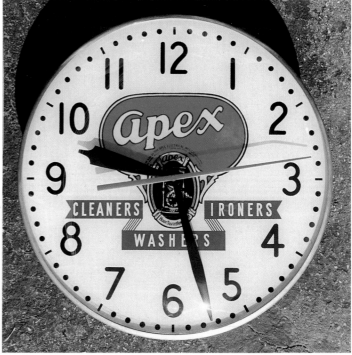

Westinghouse Radio was the company behind this 1950s clock produced by Telechron. *Author's collection.*

This Apex clock dates to around 1950. The center of the clock shows an hourglass with the slogan *"Hour Saving Appliances."* It was manufactured by Swihart, and measures approximately 15" in diameter. *Author's collection.*

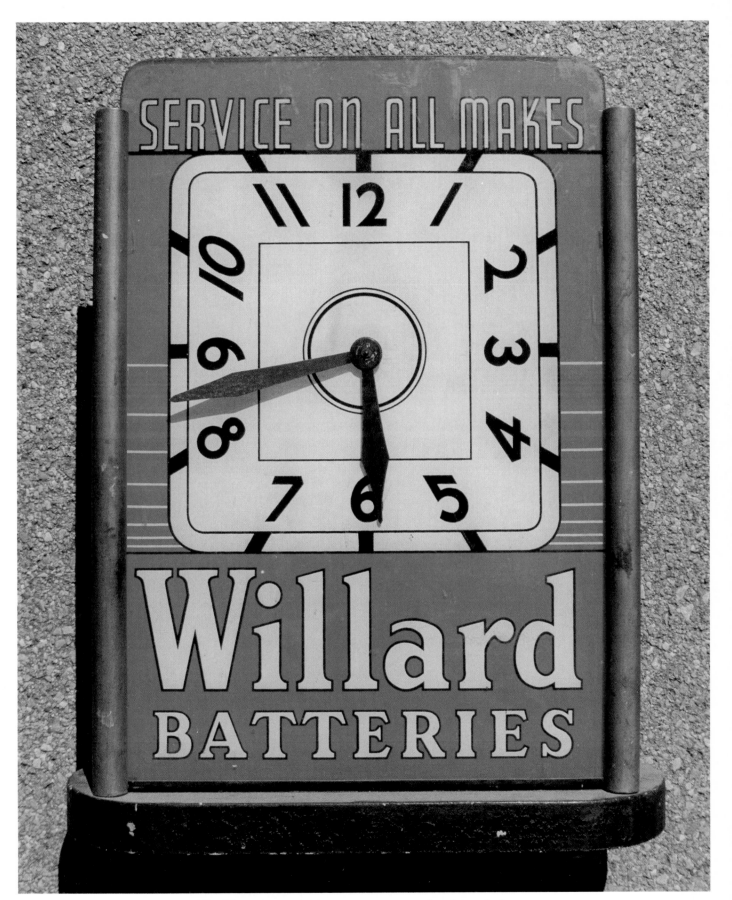

Willard Batteries used this super countertop advertising clock
in the 1930s. It has a wooden base with metal *"pilasters"* on the
sides. It measures approximately 14" x 19". *Private collection.*

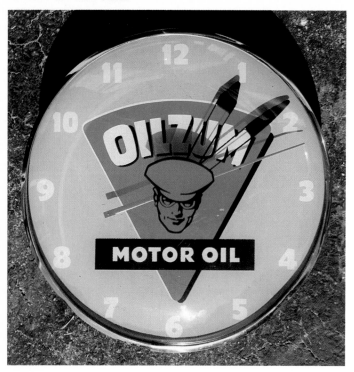

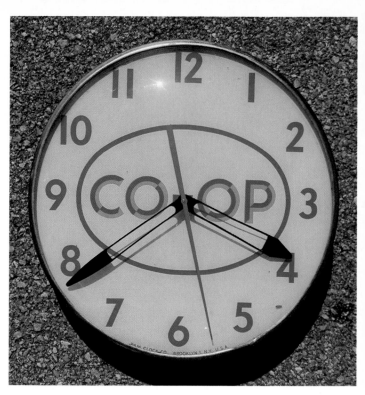

One of the most desirable brands for those collecting petroleum company advertising is Oilzum. This outstanding clock is one of several styles produced through the years for them. Most of the graphics are silk screened to the dial. However, the man's image is actually part of the outer crystal. This one was made by Telechron in the 1940s. *Author's collection.*

Nothing fancy going on here. But being fancy wasn't required to get the message across on this circa 1950s Co-Op clock. It measures 14.5" in diameter, and was manufactured by Pam Clock Company. *Private collection.*

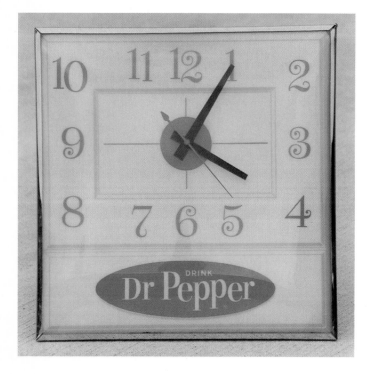

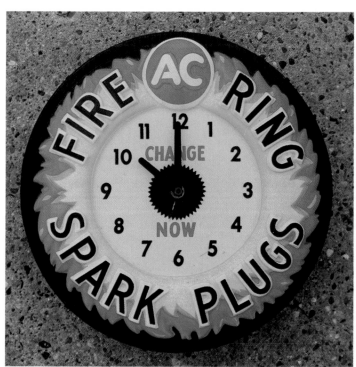

This circa 1960 Dr. Pepper clock has a plastic dial with a glass crystal. It measures approximately 14" square. *Private collection.*

This circa 1960s A-C Fire Ring Spark Plug clock must have been a mold-maker's nightmare. Its all-plastic body is comprised of four layers of bold relief embossing. Although these were produced in the hundreds, few have survived without some damage to the super-thin plastic face. It measures approximately 15" in diameter. *Courtesy of John and Cindy Ogle.*

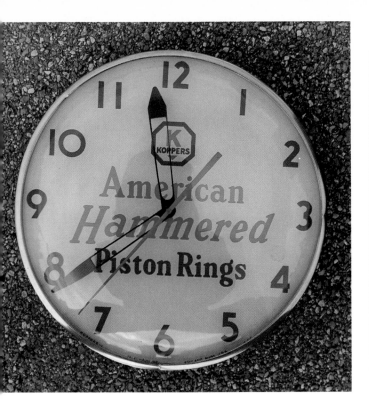

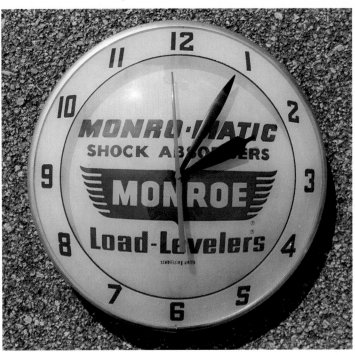

American Hammered Piston Rings used this clock in the 1960 era. It was manufactured by Telechron, and measures 14.5" in diameter. *Private collection.*

Monroe-Matic found its way into this circa 1960 *"Double Bubble"* clock. *Private collection.*

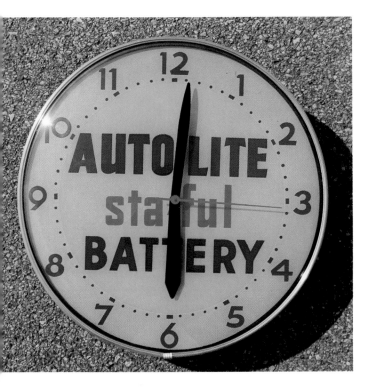

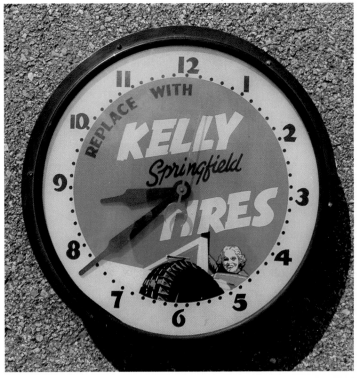

Auto-Lite had this large 18" diameter clock made for them around 1955 by an unknown manufacturer. *Private collection.*

This beautiful Kelly Springfield Tires clock is scarce. It dates to the 1930s, and was produced by an unknown manufacturer. *Private collection.*

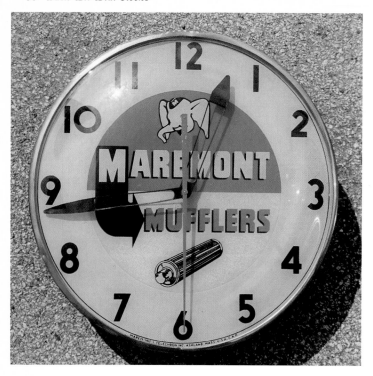

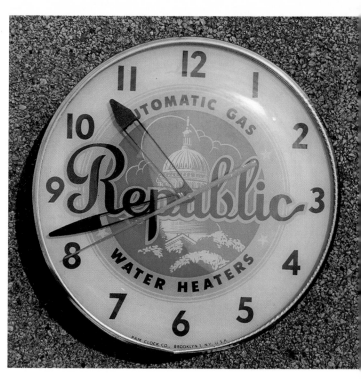

Telechron built this circa 1960 clock for Maremont Mufflers. *Courtesy of Dave Higgs.*

Pam Clock Company built this Republic Water Heaters clock in the 1950s. *Courtesy of Harold and Joanna Huddleston.*

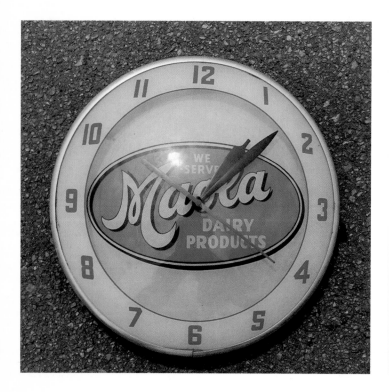

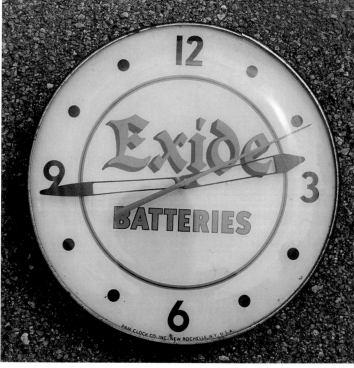

Here's another *"Double Bubble"* in action. This time, for Maola Dairy Products. *Courtesy of Trish Duque.*

Exide Batteries, circa 1955. Manufactured by Pam Clock Company. *Private collection.*

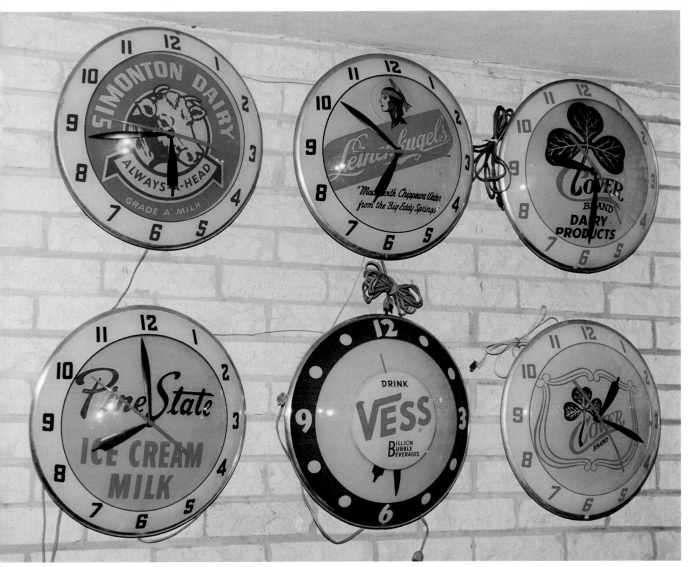

This group shot of six *"Double Bubble"* clocks shows one way to liven up empty wall space. *Courtesy of Carl Barrow.*

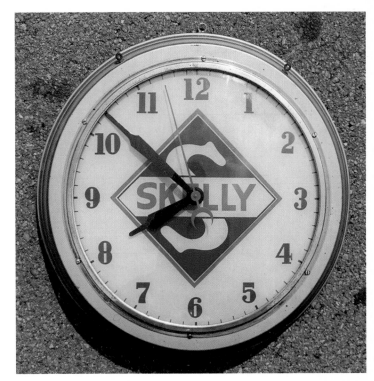

Petroleum companies were big on getting their name out to the public. This 1940s Skelly clock was produced by an unknown manufacturer. *Private collection.*

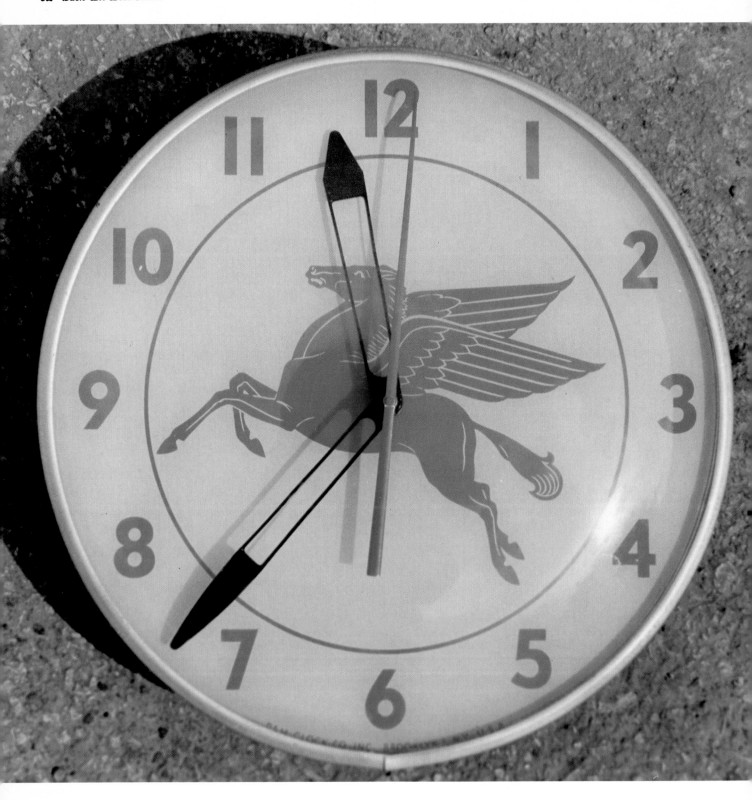

Advertising from Mobil Oil is a favorite for collectors. This circa 1950s clock features their famous *"Pegasus"* logo. It was manufactured by Pam Clock Company. *Private collection.*

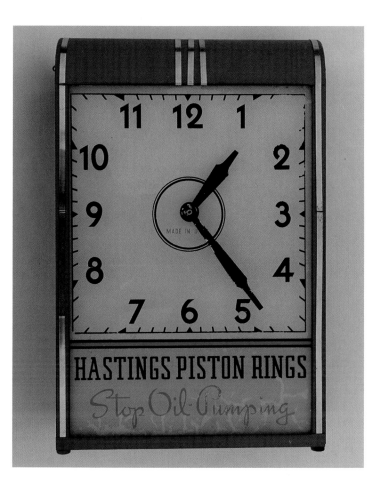

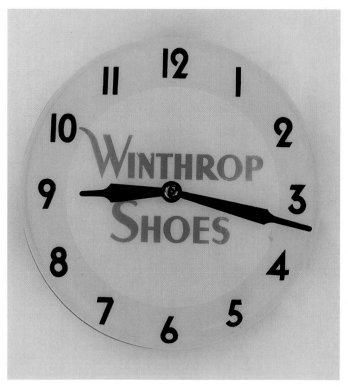

This Winthrop Shoes clock has an all-plastic front. It measures approximately 15" in diameter, and dates from the 1940s. *Courtesy of Jon and Mary Wyly, at I-29 Antique Mall.*

No manufacturer has left their name on this circa 1935 clock for Hastings Piston Rings. It measures 11.5" x 17.5". *Courtesy of Jon and Mary Wyly, at I-29 Antique Mall.*

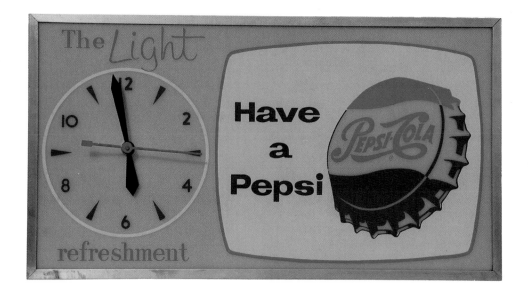

The slogan, *"The Light Refreshment,"* helps date this plastic-faced clock to the late 1950s. It measures 24" x 13". *Courtesy of John H. Johnson.*

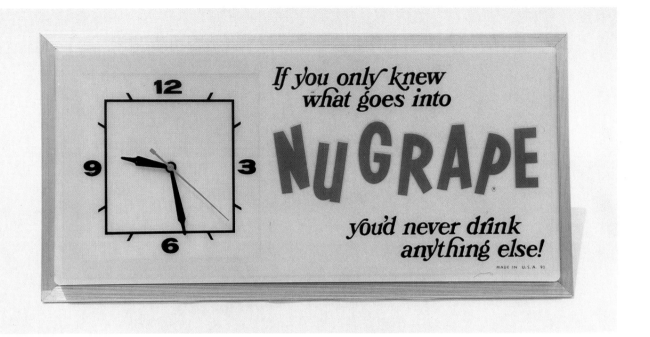

This recent vintage NuGrape clock has a plastic face. It measures 25" x 13". *Courtesy of John H. Johnson.*

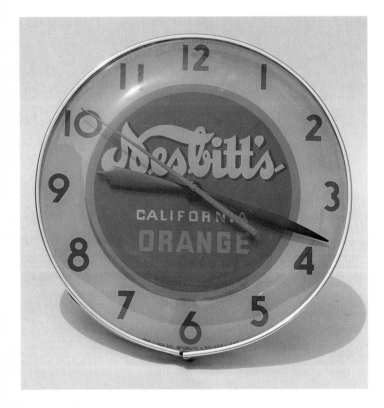

Nesbitt's California Orange used this clock in the 1960 era. Built by Pam Clock Company. *Courtesy of John H. Johnson.*

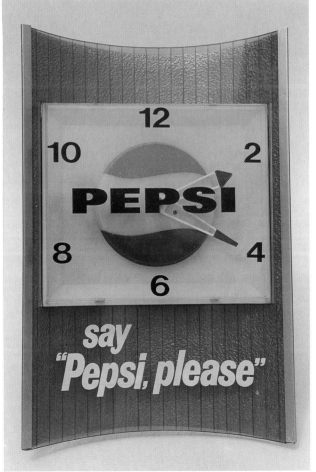

Futuristic might be one way to describe this circa 1970s Pepsi clock. It was manufactured by Price Brothers of Chicago, and measures 10.5" x 15". *Courtesy of John H. Johnson.*

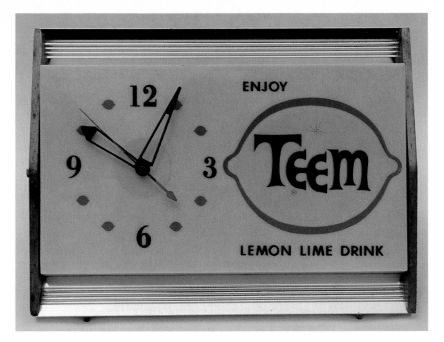

Teem was the topic of this 1960s plastic-faced clock. It measures 17" x 13" and was produced by Tel-A-Sign of Chicago. *Courtesy of John H. Johnson.*

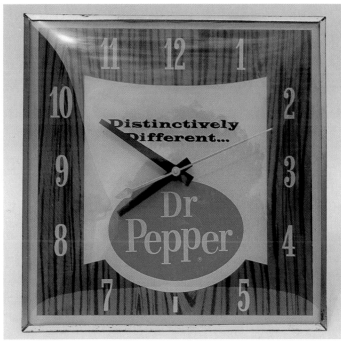

This 15.5" square Dr. Pepper clock was produced in 1971. The manufacturer is Pam Clock Company. *Courtesy of John H. Johnson.*

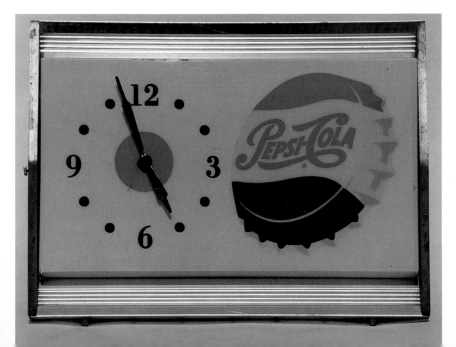

Pepsi's famous *"bottle cap"* logo is all it took to get the message across on this 1950s plastic-faced clock. It measures 17" x 12" and was manufactured by Tel-A-Sign. *Courtesy of Mike Johnson.*

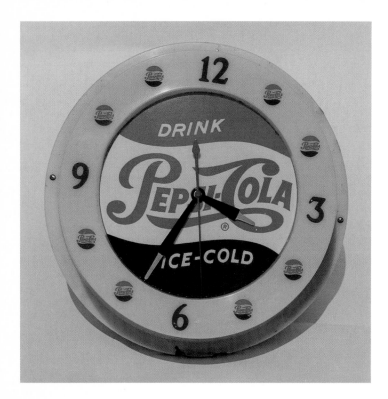

All-plastic construction was the selling point on this 11" diameter Pepsi-Cola clock. Made by an unknown manufacturer, it dates to the 1950s. *Courtesy of Mike Johnson.*

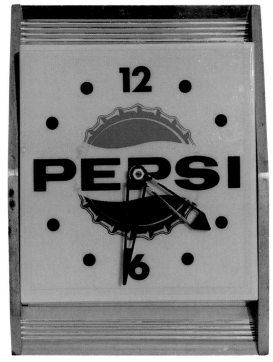

Pepsi used this plastic dial clock in the 1960s. It measures 9" x 12.5", and was manufactured by Tel-A-sign of Chicago, Illinois. *Courtesy of Dan and Nancy Wessel.*

Many of the clocks of the 1950s and 1960s were designed to be viewed as *"diamond"* shaped. Pam Clock Company was the manufacturer of this particular model. Notice the yellow dots except at 10, 2 and 4. *Courtesy of Dan and Nancy Wessel.*

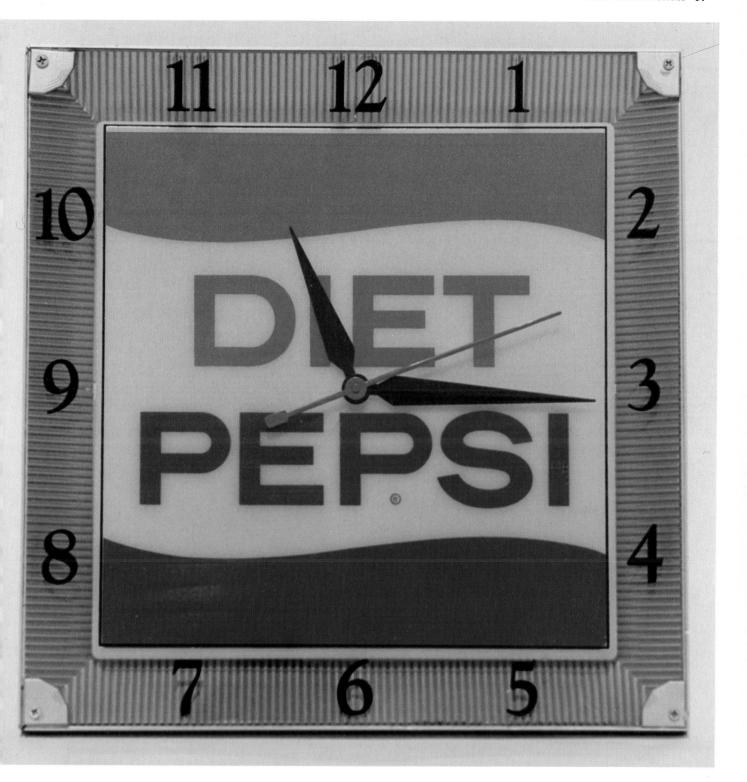

Advertising Products of Cincinnati, Ohio, was the manufacturer of this rare Diet Pepsi clock. It measures 16" square, and dates to the early 1960s. *Courtesy of Mike Johnson.*

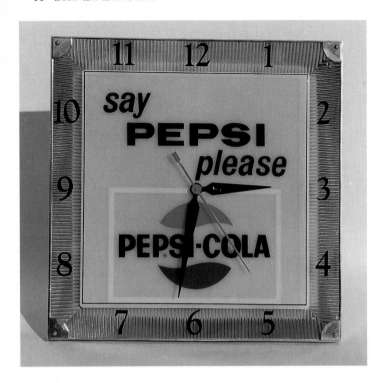

Pepsi-Cola used this clock in the 1960s. Its manufacturer was Advertising Products Company of Cincinnati, Ohio. *Courtesy of Dan and Nancy Wessel.*

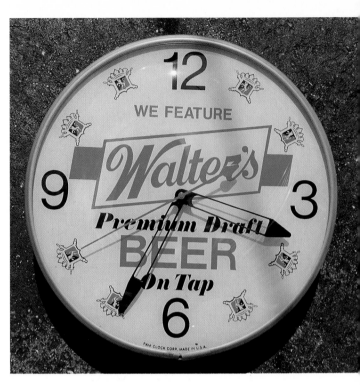

Pam Clock Company manufactured this Walter's Premium Draft Beer clock in the 1950s. Notice the logo used in place of numbers. It measures 14.5" in diameter. *Author's collection.*

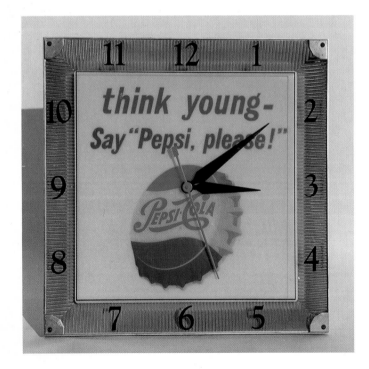

Here's another square clock on the Pepsi theme. It also dates from the 1960s, and was produced by Advertising Products Company. *Courtesy of Dan and Nancy Wessel.*

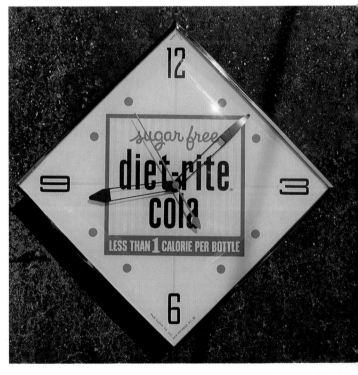

Diet-Rite Cola was a product of Royal Crown. This diamond-shaped clock was manufactured by Pam Clock Company in the 1960s. *Author's collection.*

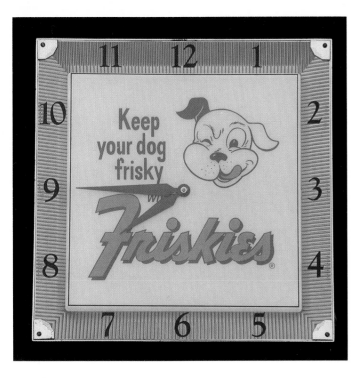

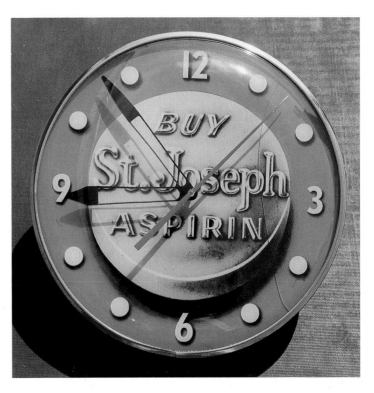

Advertising Products Company was the manufacturer of this circa 1960s Friskies clock. It measures approximately 15" square. *Courtesy of Trudy Bridge.*

A large aspirin was used as the graphics on this circa 1950s clock by Pam Clock Company. *Courtesy of Suzan and Max Mendlovitz.*

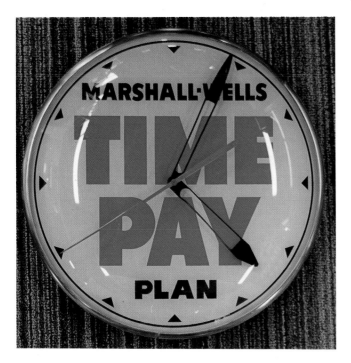

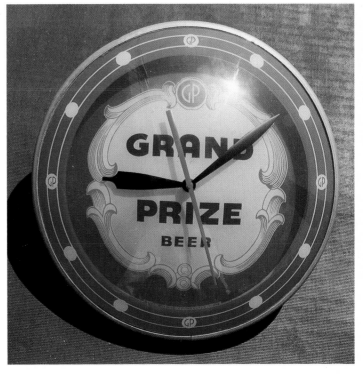

Obviously, Marshall-Wells thought the words *Time Pay* were a lot more important than their name on this 14.5" diameter clock by Telechron Clock Company. It dates to the 1960s. *Courtesy of Canal Park Antique Center.*

This *"Double Bubble"* style clock dates to the 1950s and is a product of Advertising Products of Cincinnati, Ohio. *Courtesy of Suzan and Max Mendlovitz.*

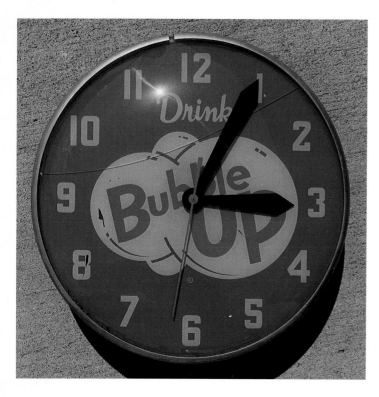

Bubble Up used this soft drink advertising clock in the 1950s. It is a product of Pam Clock Company. *Courtesy of Wizard Art Works.*

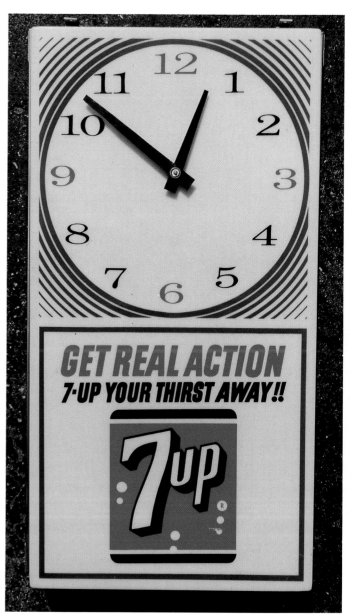

All-plastic construction was used on the face of this circa 1970 7-Up clock. It measures approximately 11" x 24". *Private collection.*

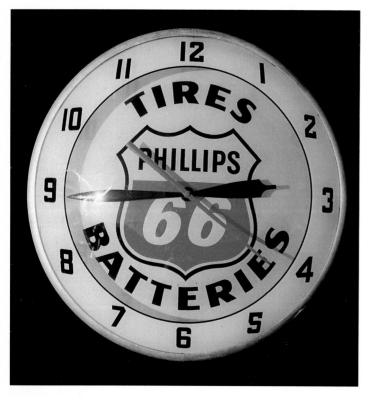

This super Phillips 66 Tires and Batteries clock dates to the 1950s. *Courtesy of Bill and Karen Brown.*

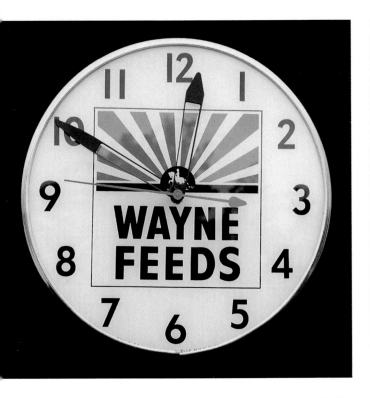

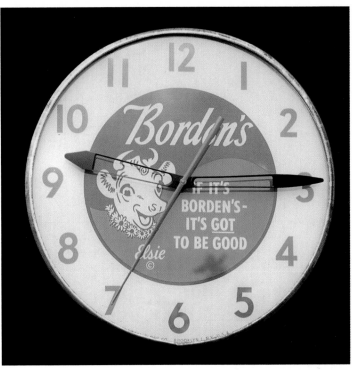

Wayne Feeds used their logo on this 14.5" diameter clock built by Pam Clock Company. It dates to the 1960s. *Courtesy of Bruce Stevens and Sons.*

"Elsie" the cow was the star on this great Borden's advertising clock by Pam Clock Company. *Courtesy of Bruce Stevens and Sons.*

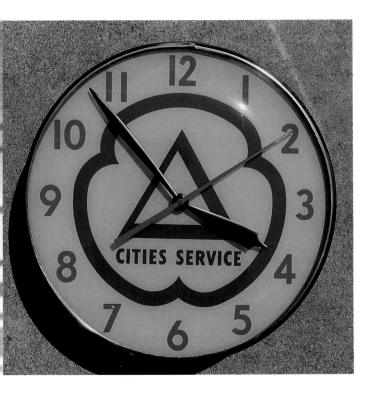

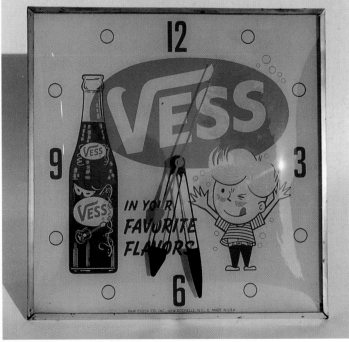

Here's another advertisement from a long line of those produced by America's petroleum companies. This one features the famous logo of Cities Service. Manufactured by Telechron in the 1950s. *Courtesy of Dave and Kathy Lane.*

1959 was the year this Vess clock was manufactured by Pam Clock Company. *Courtesy of Dan and Nancy Wessel.*

This unusual Pepsi-Cola clock was manufactured by the List-O-Mat Corporation of New York. It measures approximately 12" square, and dates to around 1945. *Courtesy of Dan and Nancy Wessel.*

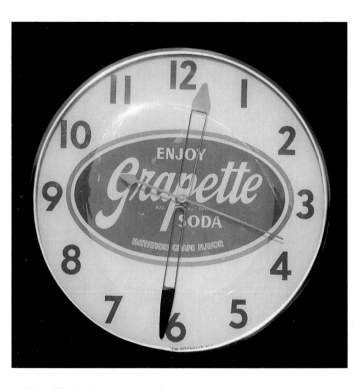

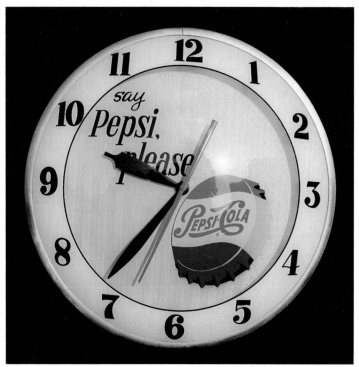

Pam Clock Company produced this 14.5" diameter clock for Grapette in the 1950s. *Courtesy of Dan and Nancy Wessel.*

This super *"Double Bubble"* style clock dates to the 1950s. It was made by Advertising Products of Cincinnati, Ohio. *Courtesy of Dan and Nancy Wessel.*

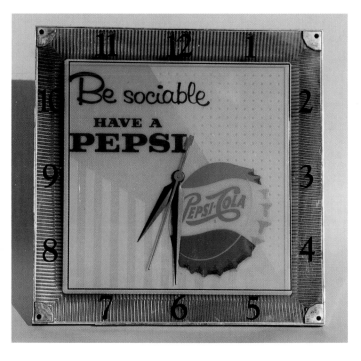

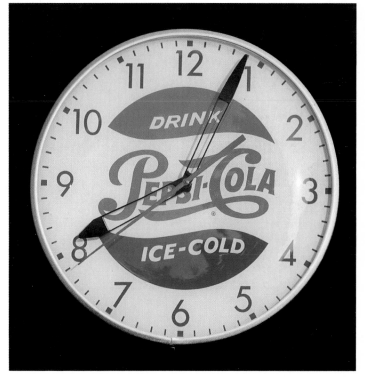

Advertising Products was the manufacturer of this circa 1960 Pepsi-Cola clock. *Courtesy of Dan and Nancy Wessel.*

Pepsi-Cola had this unusual dial made for them around 1951 by Pam Clock Company. *Courtesy of Dan and Nancy Wessel.*

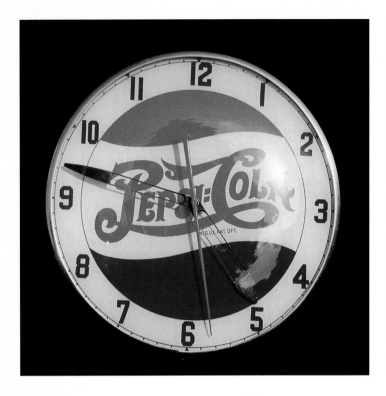

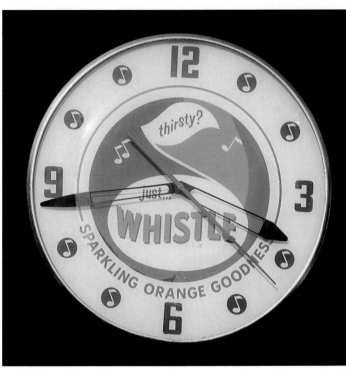

It seems like the list of clocks built for Pepsi-Cola goes on and on. This wide-logo example was manufactured by Telechron in the 1940's. *Courtesy of Dan and Nancy Wessel.*

This Whistle Clock was produced by Pam Clock Company in the 1950s. *Courtesy of Dan and Nancy Wessel.*

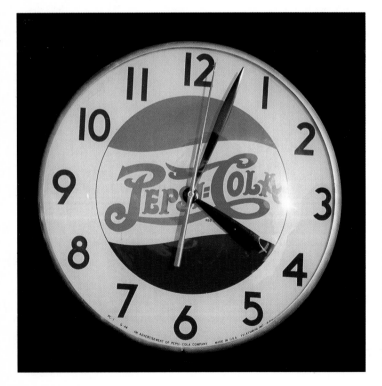

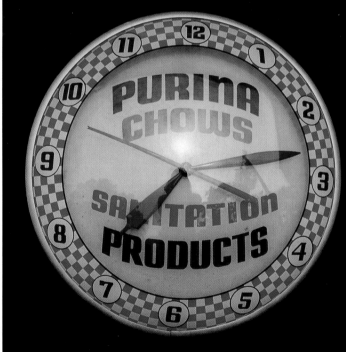

Telechron was the producer of this 1940s Pepsi-Cola clock. *Courtesy of Dan and Nancy Wessel.*

Purina's familiar *"checkerboard"* design was utilized in this 1950s *"Double Bubble"* clock by Advertising Products Company. *Author's collection.*

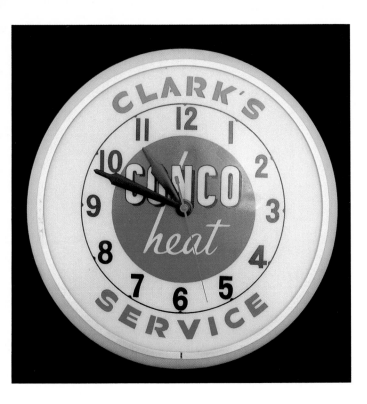

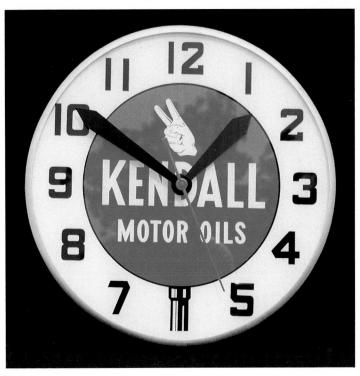

Duralite of Cincinnati, Ohio, was the manufacturer of this Conco Heat clock. Note that the local distributor's name was placed on the clock's perimeter. *Courtesy of Bruce Stevens and Sons.*

Kendall Motor Oils had a variety of designs used on their advertising clocks. This one was made to represent a sidewalk lolli-pop sign. The manufacturer is Swihart Products of Ellwood, Indiana. It dates to the 1950s. *Courtesy of Bruce Stevens and Sons.*

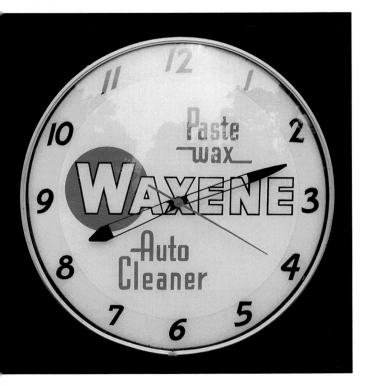

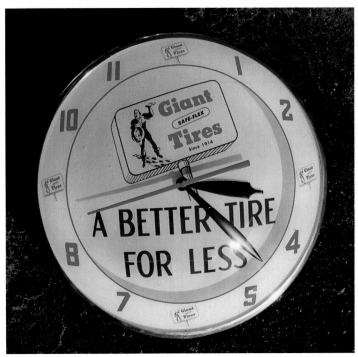

Waxene Auto Cleaner used this advertising clock in the 1950s era. It measures 18" in diameter, and was produced by Lackner of Cincinnati, Ohio. *Courtesy of Bruce Stevens and Sons.*

A better tire for less brought attention to this circa 1950s *"Double Bubble"* clock for Giant Tires. *Author's collection.*

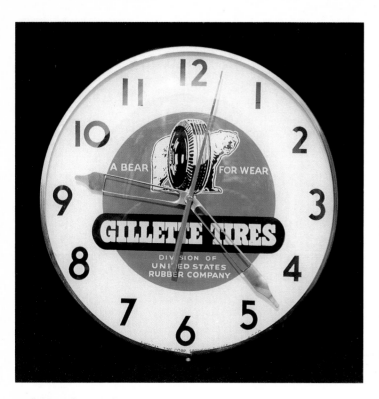

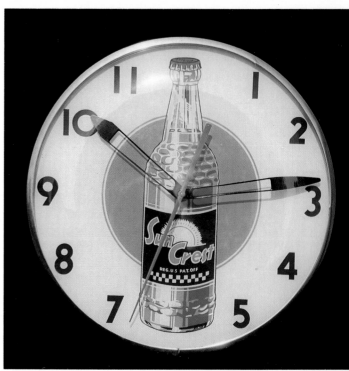

"A Bear for Wear" was the slogan on this super Gillette Tires clock of the 1950s. The manufacturer was Telechron. *Author's collection.*

There's nothing like featuring your product on the dial to get the maximum impact. Sun Crest did just that on this circa 1950s clock built by Telechron. *Author's collection.*

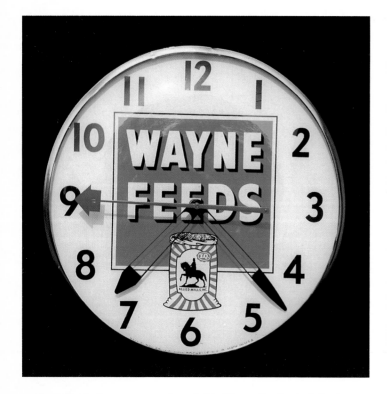

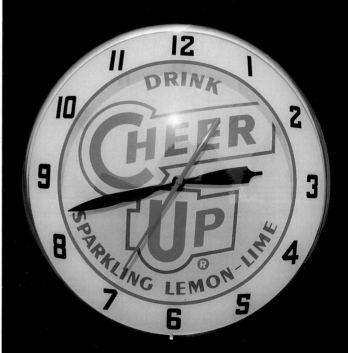

Pam Clock Company produced this Wayne Feeds clock in the 1950s. *Author's collection.*

This scarce Cheer Up *"Double Bubble"* clock was manufactured in the 1950s. *Author's collection.*

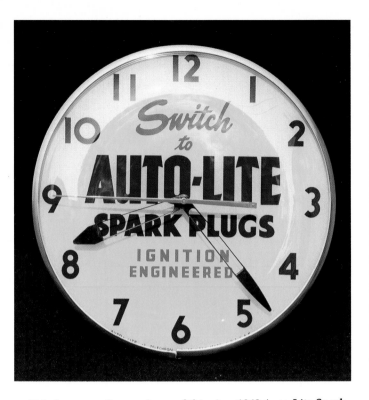

Telechron was the producer of this circa 1960 Auto-Lite Spark Plugs clock. *Author's collection.*

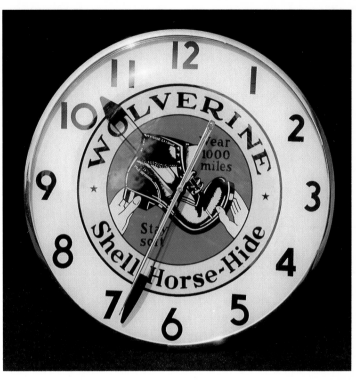

Superior graphics were used by Telechron to feature Wolverine Boots. It measures 14.5" in diameter, and dates to the 1950s. *Author's collection.*

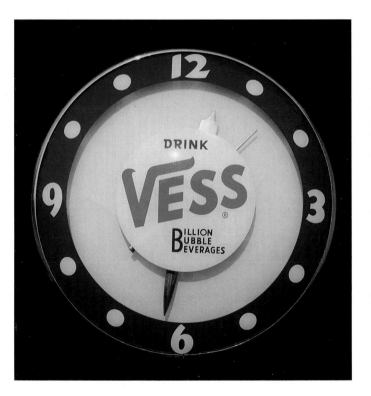

Here's another of the hundreds of *"Double Bubble"* clocks that were produced by Advertising Products of Cincinnati, Ohio. This one is for Vess, and has their catch phrase *Billion Bubble Beverages. Author's collection.*

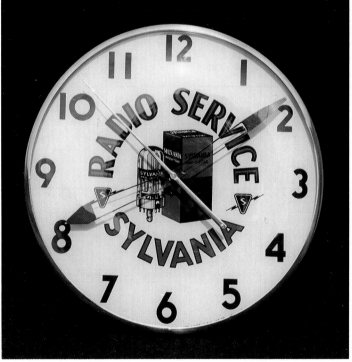

Radio Service was big business when this clock was manufactured in the 1950s era by Telechron. *Author's collection.*

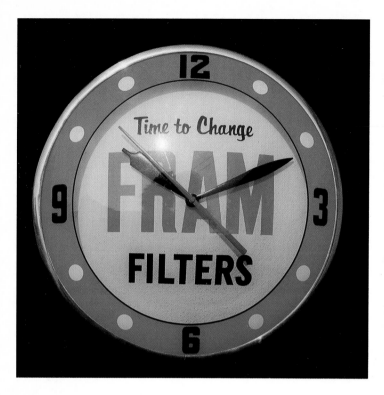

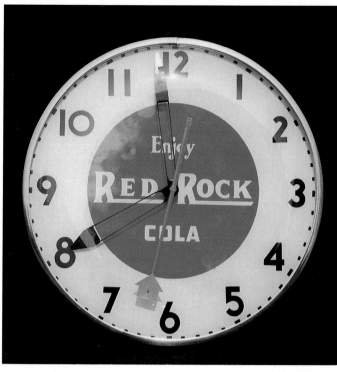

Fram Filters used this *"Double Bubble"* clock in the 1950s. *Author's collection.*

Some of the clocks produced by Telechron used a thin plastic arrow that was attached to the end on the second hand. This example features Red Rock Cola, and dates to around 1955. *Author's collection.*

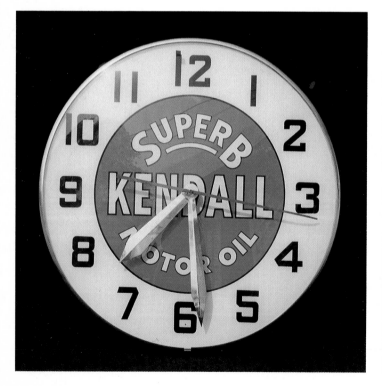

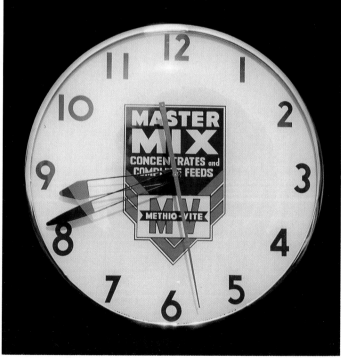

Here's another variation of advertising for Kendall Motor Oil. It's a large one, measuring approximately 20" in diameter. *Author's collection.*

Master Mix Feeds used this clock in the 1950s. It was built by Telechron. *Author's collection.*

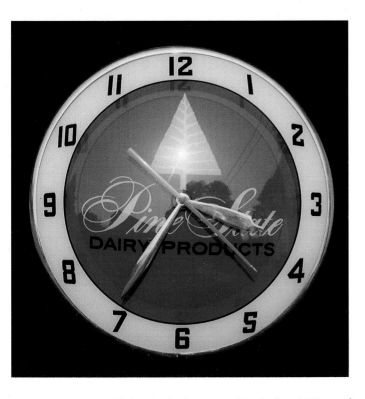

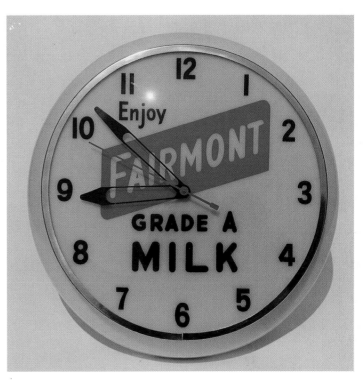

This *"Double Bubble"* style clock was used in the late 1950s, and features Pine State Dairy Products. *Author's collection.*

Here's another example of graphics used on a Fairmont Grade A Milk clock. Made by Dualite in the 1950s. *Author's collection.*

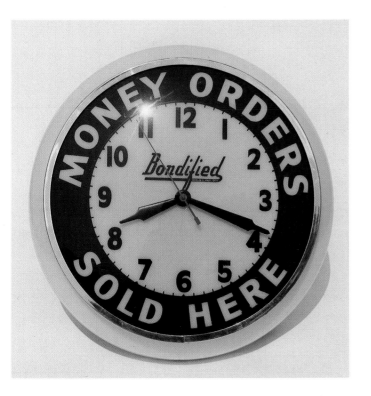

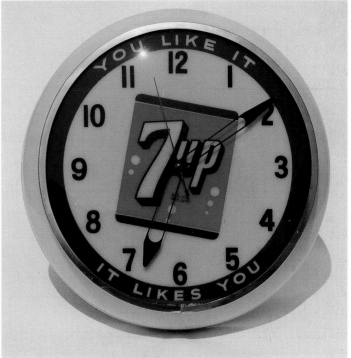

Dualite Displays Incorporated of Cincinnati, Ohio, was the producer of this Bondified Money Orders clock, circa 1955. *Author's collection.*

This scarce 7-Up clock was produced by Dualite in the 1950s era. *Author's collection.*

Postal Telegraph used two types of advertising clocks in the period around the 1930s. Most of their clocks were metal bodied, with a baked-enamel metal dial. The clock photographed here is the *"other"* one. This clock featured a deco style body with a reverse painted glass dial. It was back-lit with a series of C-9 bulbs. It measures approximately 20" in diameter, and was manufactured by the Hammond Instrument Company. *Author's collection.*

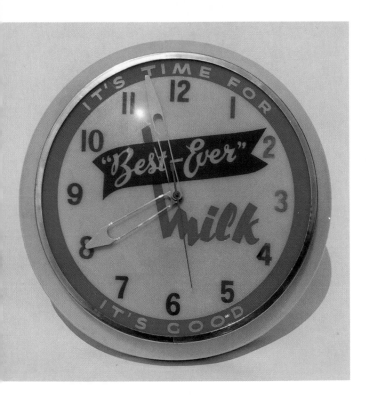

The next few photos will give you an idea as to the capabilities of back-lit dial clocks in daylight as well as at night.

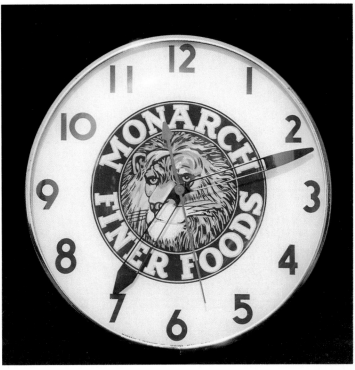

Best-Ever was the featured company on this circa 1955 Dualite clock. *Author's collection.*

Monarch Finer Foods were in business since the early years of the century. Although this beautiful clock dates from the 1950s, the logo featured on its dial had been their trademark for many years previous to this time. Manufactured by Telechron. *Author's collection.*

The Monarch at night.

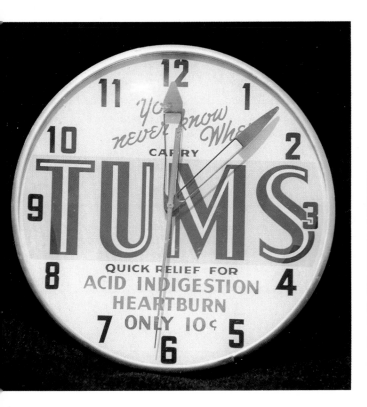

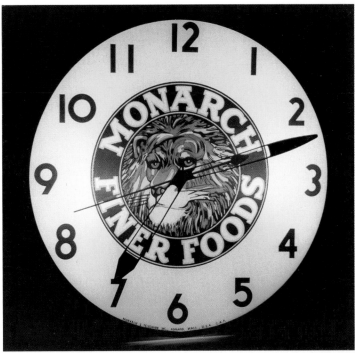

This super Tums clock is still in service in a general store in Michigan's north woods. You never know where or when something will turn up. It dates from the 1940s and is a product of Telechron. *Courtesy of Nancy Golpe.*

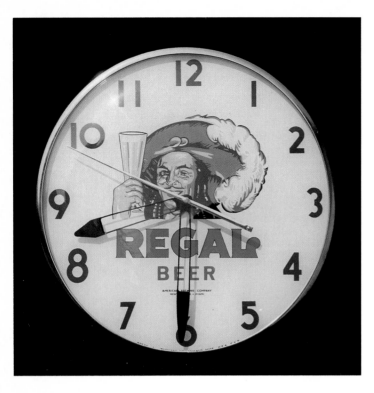

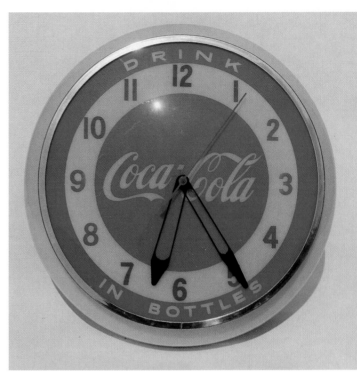

Outstanding graphics make this Regal Beer clock a winner. It was produced by Telechron in the 1950s, and measures 14.5" in diameter. *Courtesy of Dennis Weber.*

Coca-Cola was always one of America's leading soft drink advertisers. You wouldn't know it though by the amount of their advertising clocks that are available on the market. Obviously, there have been plenty of willing buyers. This 1940s clock by Dualite is a beauty. *Author's collection.*

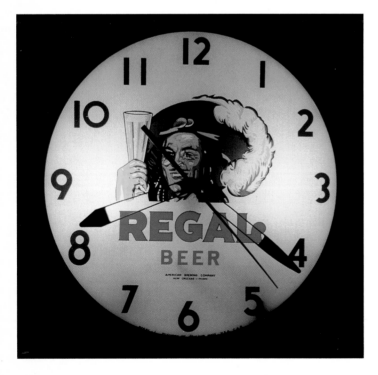

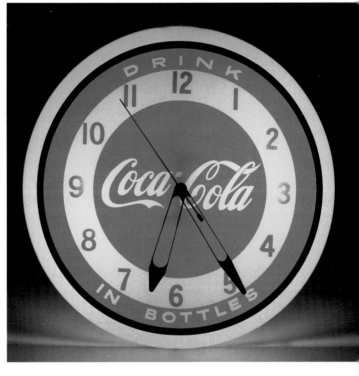

The Regal Beer clock at night.

As usual, Dualite clocks come alive at night.

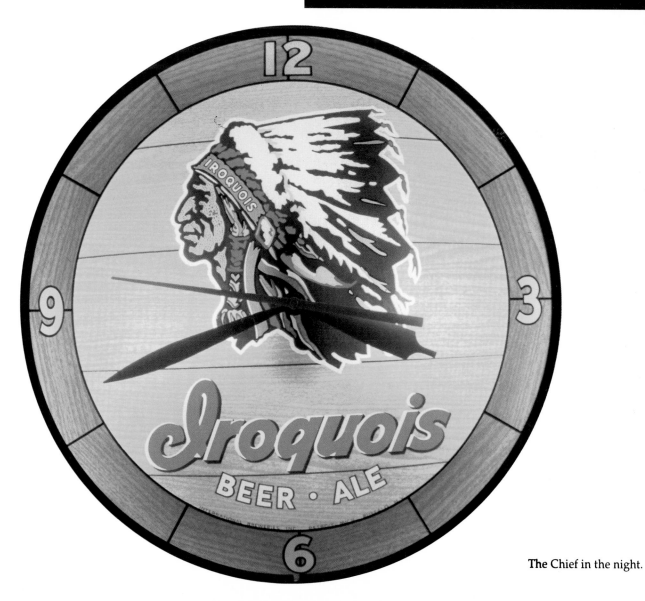

Iroquois Beer and Ale have one of the most outstanding back-lit clocks to be found anywhere. The graphic Indian with full head dress is an attention-getter for sure! Advertising Products Incorporated was the manufacturer of this circa 1950s gem. *Author's collection.*

The Chief in the night.

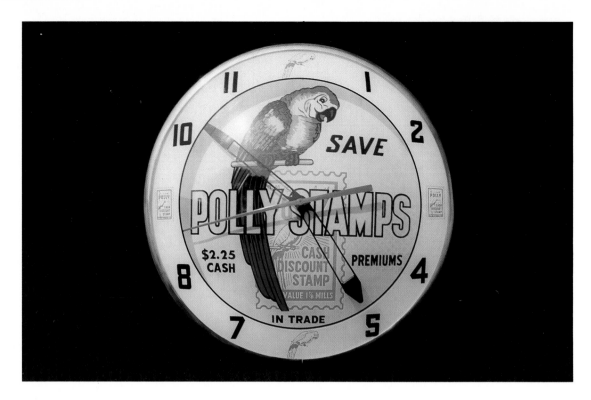

Polly Stamps had this *"Double Bubble"* style clock produced in the 1950s. Being graphically complicated, it scores big with collectors. Notice the stamps and birds in place of numbers on the dial. Manufactured by Advertising Products Incorporated. *Author's collection.*

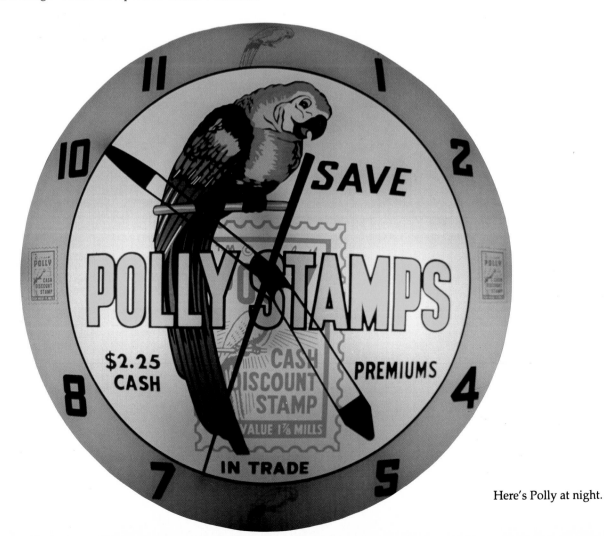

Here's Polly at night.

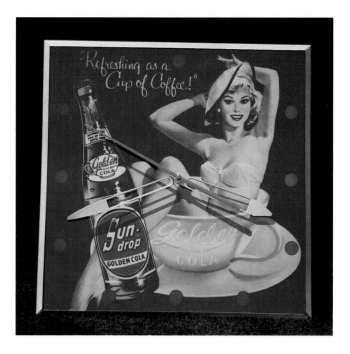

This magnificent Sun-Drop Golden Cola clock is beauty personified. Although the bottle of Sun-Drop Cola was the focus on this circa 1960 clock, the girl in the cup no doubt got most of the attention! It measures 15.5" square, and was produced by Pam Clock Company. *Author's collection.*

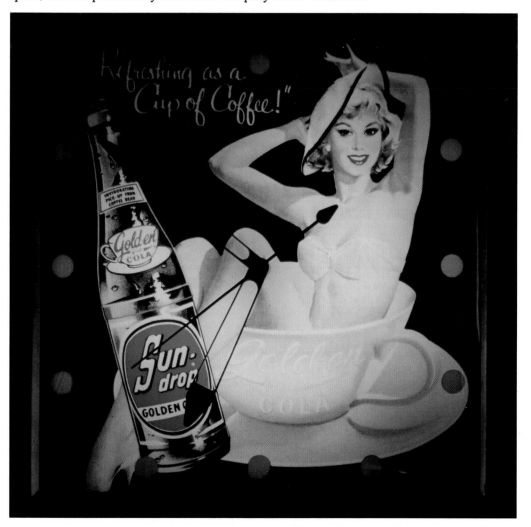

This photo shows how it looks at night. What a clock!

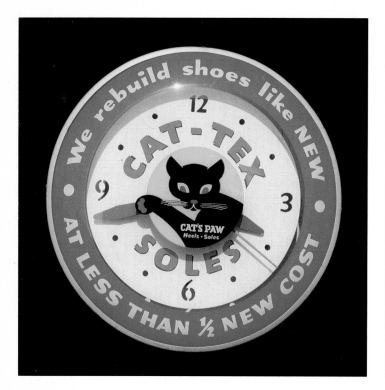

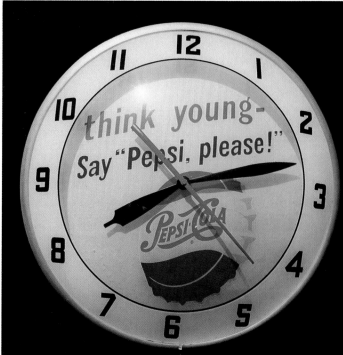

Cat's Paw used this outstanding example of clock advertising in the 1950s. It was produced by Advertising Products, and has numbers that were stamped out of the dial. Their *"black cat"* logo was silk-screened on the outer crystal. *Author's collection.*

Pepsi-Cola is the theme on this circa 1960 *"Double Bubble"* clock. All of the variations of these Pepsi clocks make it difficult to acquire a *"set"* of six. It's definitely possible to obtain them all, but you need patience and, no doubt, an extended checkbook! *Courtesy of Roger Blad.*

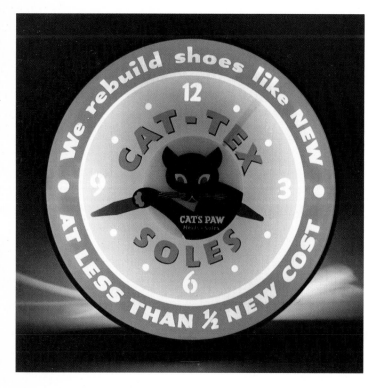

Here's a shot of the manufacturer's label on the back of a *"Double Bubble."*

Here's a *"cat in the night."* Notice how the die-cut numbers pass light from the back-lit dial.

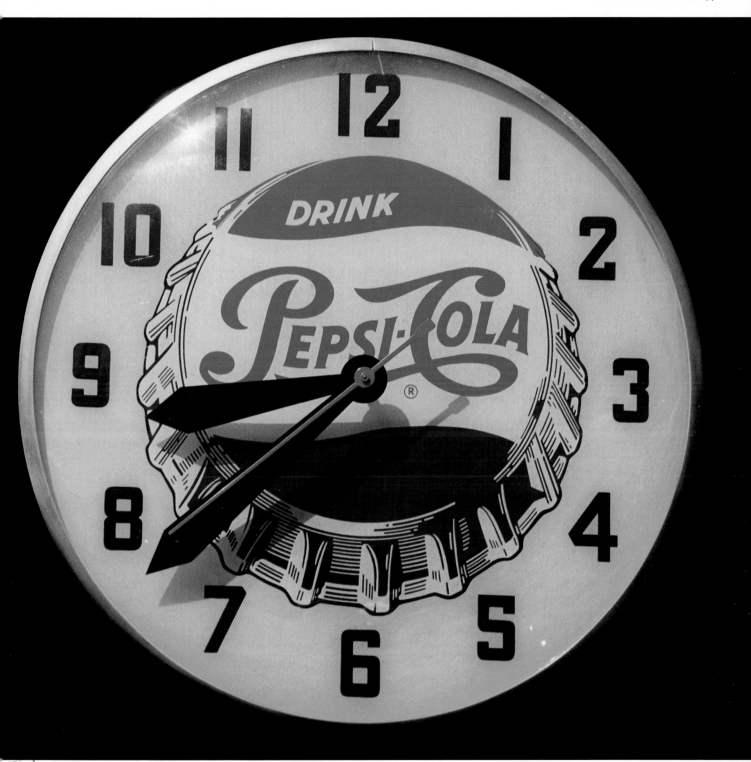

Most Pepsi clocks were produced with a white background dial. This unusual model features their *"bottle-cap"* logo on a yellow background. It was manufactured by Swihart Products of Elwood City, Indiana. *Courtesy of Roger Blad.*

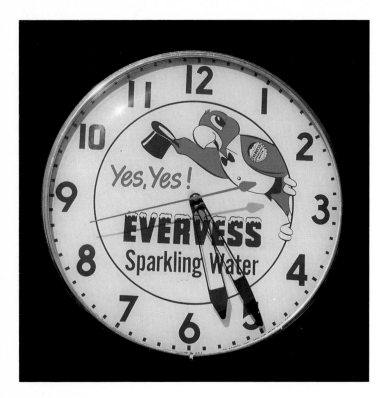

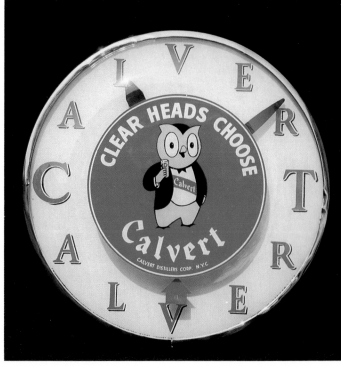

Evervess Sparkling Water was a product of the Pepsi-Cola Company. This circa 1950 clock was manufactured by Telechron. *Courtesy of Roger Blad.*

Sometimes, advertising clocks could be found without dial numbers. Such is the case on this beautiful Calvert back-lit clock by Telechron. This particular model features their famous owl logo silk screened on the crystal, with the word *"CalverT"* on the dial. *Author's collection.*

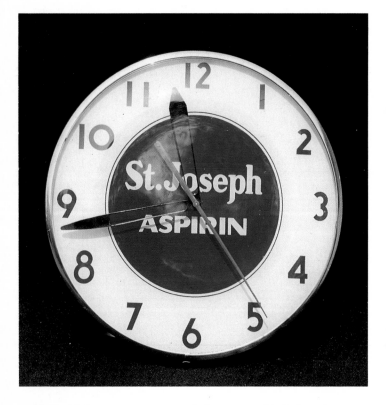

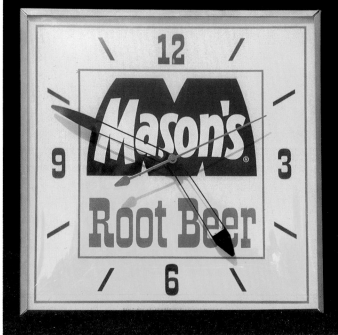

The local drug store was a good place to see this St. Joseph Aspirin clock in the 1950s. Now, of course, the best viewing spot will be in your collection! *Courtesy of Luther and Murphy Gordon.*

Pam Clock Company was the manufacturer of this circa 1950s Mason's Root Beer clock. It measures 16" square. *Courtesy of Roger Blad.*

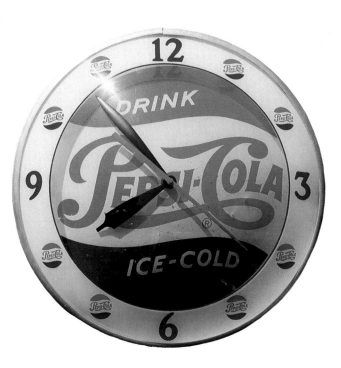

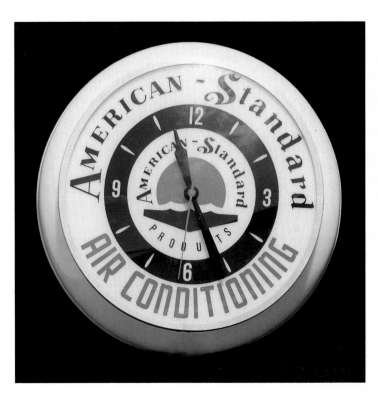

Pepsi-Cola had this beautiful *"Double Bubble"* style clock manufactured for them in the 1950s. The use of their logo around the outside crystal makes this particular clock one of the most desirable for Pepsi-Cola memorabilia collectors. *Courtesy of Roger Blad.*

Dualite Displays of Cincinnati, Ohio, produced this clock for American-Standard Air Conditioning in the era around 1960. *Courtesy of Fox River Antique Mall.*

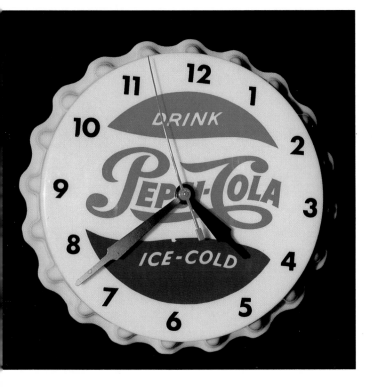

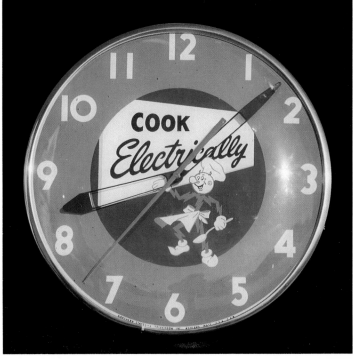

Few of these *"bottle cap"* molded plastic clocks were produced. The one shown here was manufactured by Tommy Tucker Plastics of Dallas, Texas, and measures only 11" in diameter. *Courtesy of Roger Blad.*

Some of the *"hottest"* new collectibles on the market today are those featuring the energetic figure of *"Reddy Kilowatt."* This super Cook Electrically advertisement was created for the Northern States Power Company, and was manufactured by Telechron in the 1950s. It measures 14.5" in diameter. *Courtesy of Darryl Tilden.*

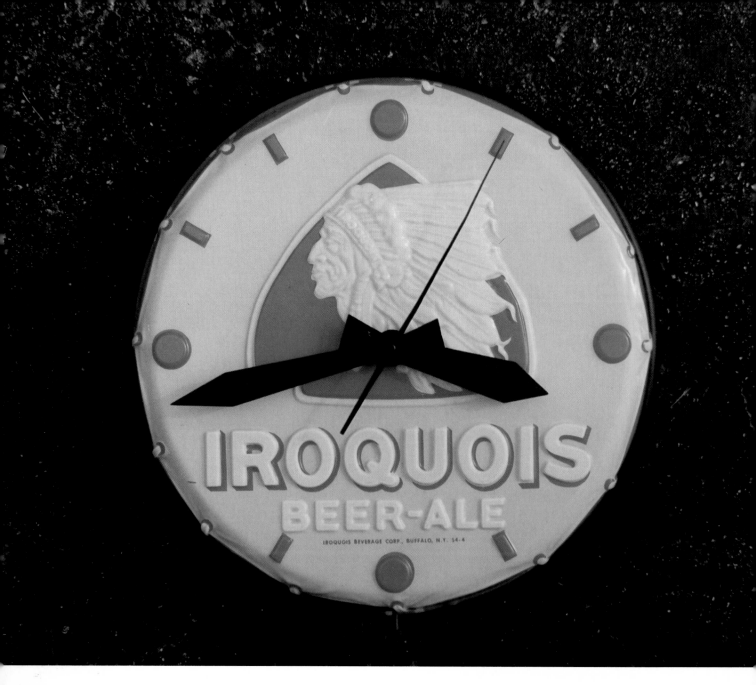

This outstanding Iroquois Beer-Ale clock was manufactured with a sheet steel back and a molded high-relief plastic front. The beautifully embossed Indian makes this clock a winner! It was produced in the 1950s by The Rotary Company Incorporated of Buffalo, New York, and measures 18" in diameter. *Courtesy of Bob Kozar.*

Here's a photograph of the factory label that is on the back side of the Iroquois clock. Notice that the completion date is ink-stamped just below the label. It's a shame this was such an uncommon practice, as collectors appreciate such small details. *Courtesy of Bob Kozar.*

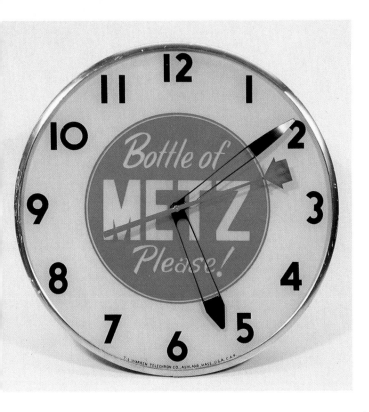

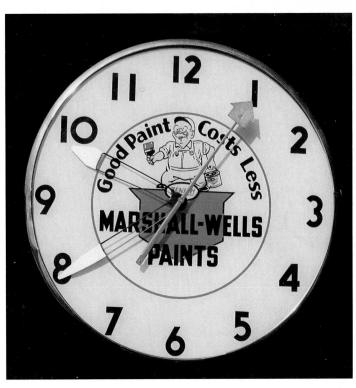

Most everyone would like a clock with their name on it. Gary Metz of Roanoke, Virginia, was lucky enough to come across this circa 1960 clock manufactured by Telechron. It measures 14.5" in diameter. *Courtesy of Gary Metz.*

Marshall-Wells Paints had this clock produced for them by Telechron in the 1950s. *Courtesy of Darryl Tilden.*

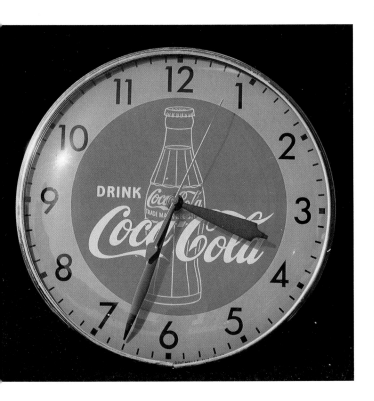

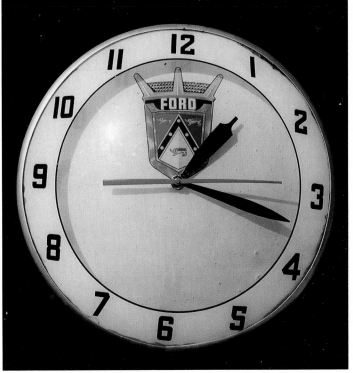

This four-color Coca-Cola clock is a scarce variety. It was built by Pam Clock Company, and dates to the 1950s. *Courtesy of Darryl Tilden.*

Ford Motor had this *"Double Bubble"* style clock produced for them in the 1950s. The small size and unusual placement of the logo might have been to facilitate the dealership in placing their name in the open area on the bottom half. Whatever the case, this clock is a rare breed! *Courtesy of Darryl Tilden.*

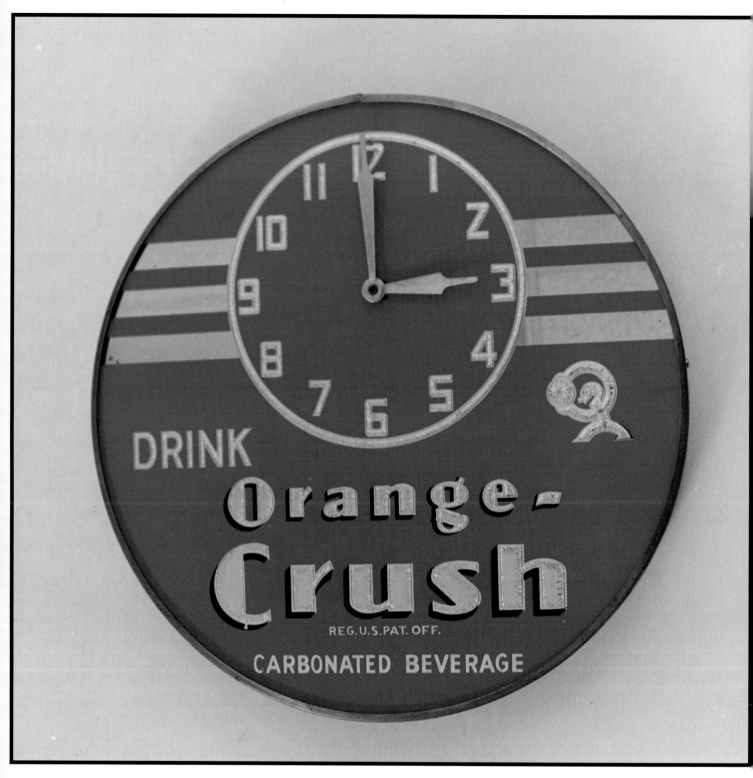

Here's an outstanding example of soda advertising. This
beauty was manufactured with a *"silvered"* look to the letters,
numbers, and the logo. It dates to the era around the 1940s.
Courtesy of Earl Bender.

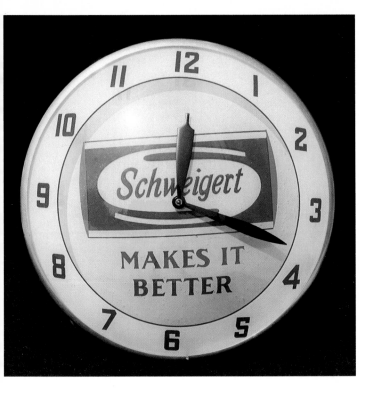

Schweigert was the topic on this *"Double Bubble"* clock of the 1950s. *Courtesy of Darryl Tilden.*

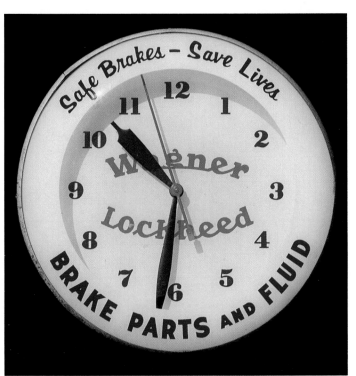

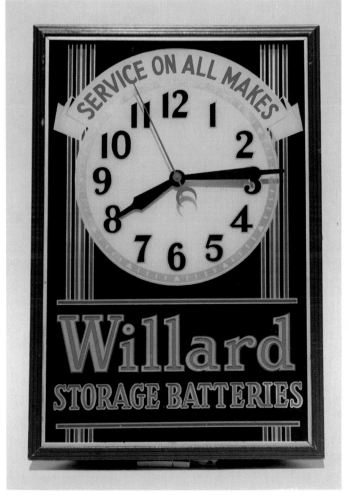

Outstanding graphics abound in this circa 1930s clock for Willard Storage Batteries. The multi-colored silk-screened face has its lettering and dial numbers trimmed in a mirror-like material. The other colors pass light through them with the exception of areas that are black. It measures approximately 17" x 26", and was manufactured by Crystal Manufacturing Company of Chicago, Illinois. *Author's collection.*

Advertising Products of Cincinnati, Ohio, was the manufacturer of this Wagner Lockheed clock of the era around 1950. Besides making their famous double-bubble clocks, Advertising Products built clocks with silk-screened advertising on the outer crystal, as well as on a metal dial. Although the example shown here has a *"solid"* dial, many of A-P's clocks had stamped-out numbers that allowed the back lighting to not only go around the perimeter of the dial, but pass through the numbers as well. *Courtesy of Darryl Tilden.*

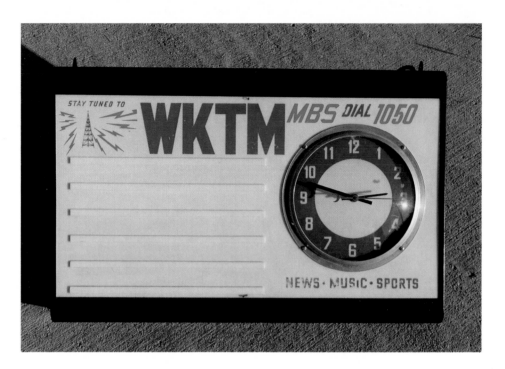

WKTM Radio 1050 used this unusual *"announcement board"* type clock in the era around the 1940s. The area at the left has *"channels"* on which interchangeable letters can be placed to create a customized message. It measures approximately 27" x 14". *Courtesy of Dave Higgs.*

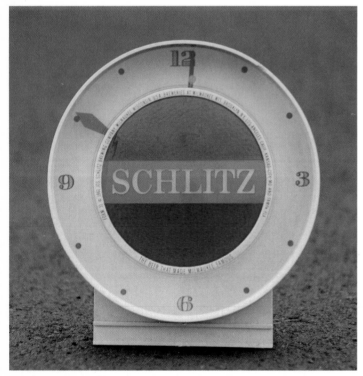

The 1960s saw the production of this small-size Schlitz clock. The dial measures approximately 8" in diameter, and it's manufactured of plastic. Notice the small second hand that traveled around the perimeter of the advertisement. *Courtesy of Memories Antique Mall.*

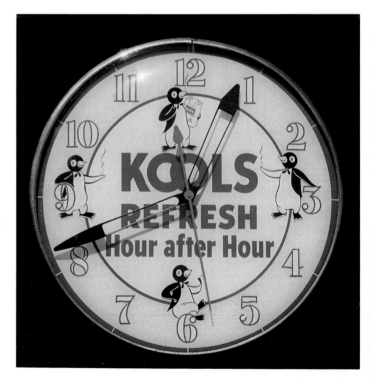

The graphics on this circa 1950s Kools clock are super. The *"penguin"* trademark was used four times on the dial, and each one of them shows him in a different position! The clock was produced by Pam Clock Company, and measures 14.5" in diameter. *Courtesy of Roger Blad.*

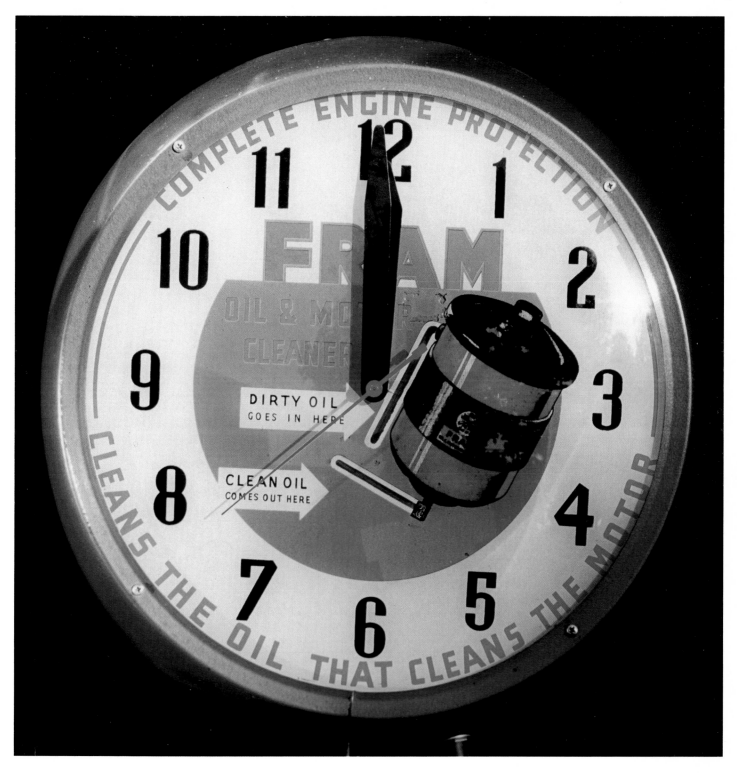

This fantastic Fram Filters clock had its hour and minute hands purposely set at noon so that the oil filter could be seen. If you look closely, you'll notice the two dark *"lines"* that are bordered in white near the filter. These are actually non-silk-screened areas that allowed light from a *"bubbler"* tube under the dial to be viewed. The tubes were filled with a liquid, and heat would make the liquid travel through the tubes. A dark amber filter was placed on the upper tube to give the fluid a *"dirty"* appearance. The lower tube used a light amber filter for a *"clean"* oil look. Unfortunately, these great display clocks used a poor technique of silk screening, and the author wonders if one of these clocks even exists in original condition. Coupled with this, the fragile bubbler tube was always the first thing to break. Despite all this, the example shown here is an exceptional tribute to advertising clock design. *Courtesy of Gene Sonnen.*

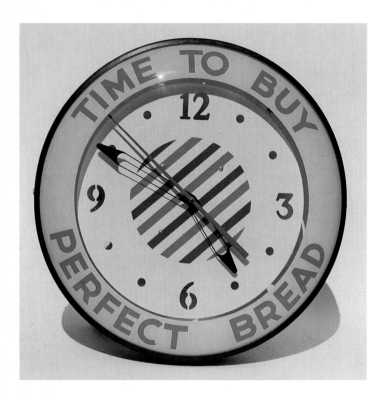

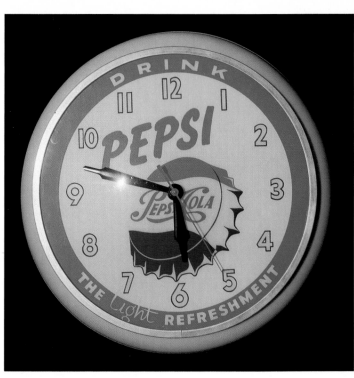

Perfect bread was the company behind this 1950 era clock by Advertising Products. Notice that the numbers have been stamped out of the dial to create back-lighting. *Author's collection.*

This rare Pepsi clock was manufactured by Dualite Display Incorporated in the 1950s. Fortunately, no one put high wattage bulbs in the clock, as its condition is like new. *Courtesy of Roger Blad.*

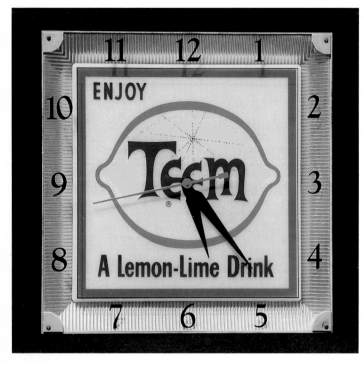

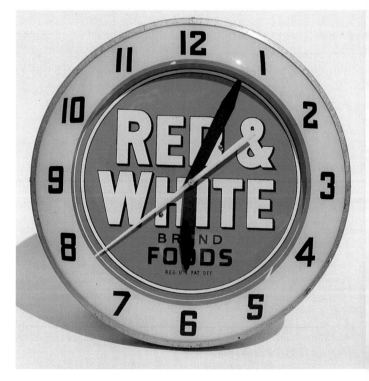

Teem's logo was the centerpiece on this Advertising Products clock of the 1960s. It measures 16" square. *Courtesy of Roger Blad.*

Red & White Brand Foods used this clock in the 1950s. It was produced by Advertising Products of Cincinnati, Ohio. *Author's collection.*

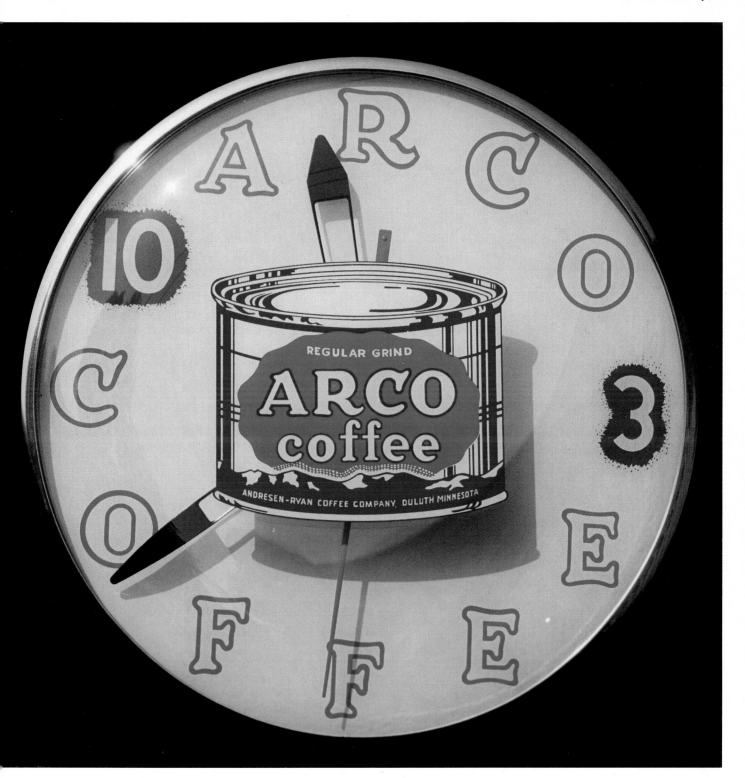

This great-looking circa 1950s Arco Coffee clock was telling the customer that their coffee should be a twice-a-day habit. The use of letters in place of numbers on the dial just happened to be the right amount of space needed for their product name. It measures 14.5" in diameter, and was produced by Telechron. *Author's collection.*

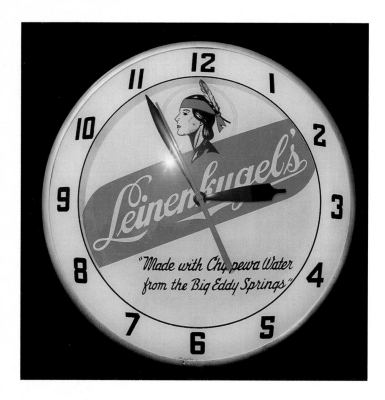

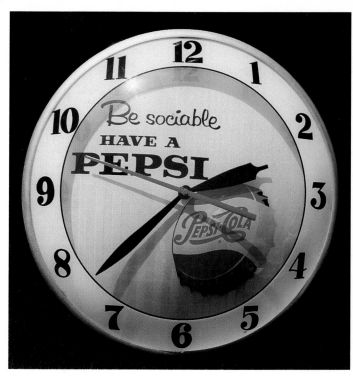

Leinenkugel's used this gorgeous *"Double Bubble"* style clock in the 1950s. The use of an Indian maiden helps put this one on collectors' wanted lists. *Author's collection.*

Here's one more for you on the Pepsi theme in the sought-after *"Double Bubble"* design. It dates to the 1950s. *Courtesy of Roger Blad.*

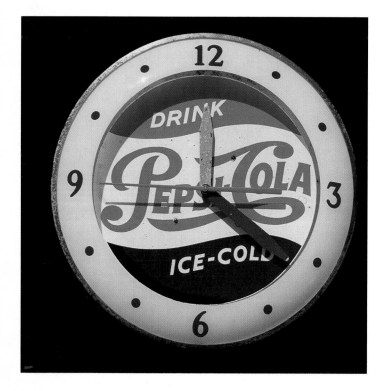

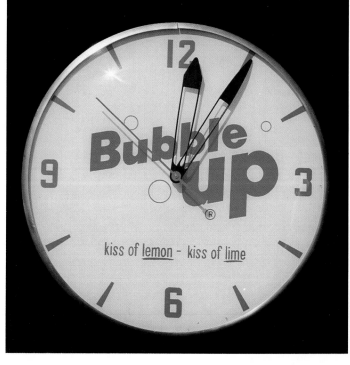

Pepsi-Cola used a variety of manufacturers for their clocks through the years. This one dates to the early 1950s, and was produced by Advertising Products. *Courtesy of Roger Blad.*

Bubble Up used this 14.5" diameter clock in the era around 1960. It was manufactured by Swihart Products of Elwood City, Indiana. *Courtesy of Roger Blad.*

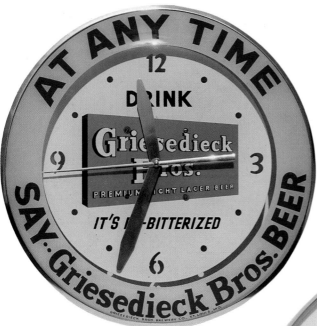

Advertising Products manufactured this circa 1950s clock that asked the customer to say *"Griesedieck Brothers Beer."* Although that may have been somewhat difficult, it still got the message across with its eye-catching graphics. *Author's collection.*

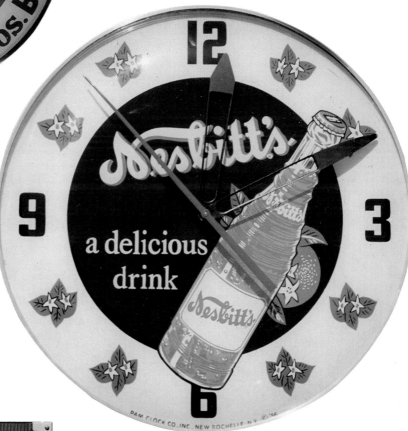

Few of the 1950s back-lit dial clocks can rival the exceptional graphics found on this beautiful Nesbitt's clock. The use of the soda bottle along with their placing orange leaves on the dial created one of the most eye-catching designs ever created by Pam Clock Company. *Courtesy of Roger Blad.*

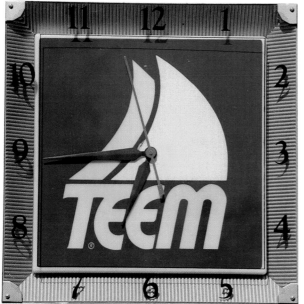

Teem used the logo on this clock around the 1960s era. It measures 16" square, and was manufactured by Advertising Products. *Courtesy of Roger Blad.*

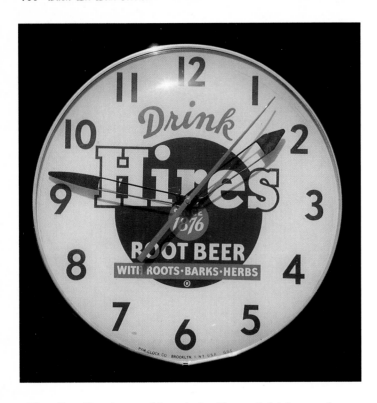

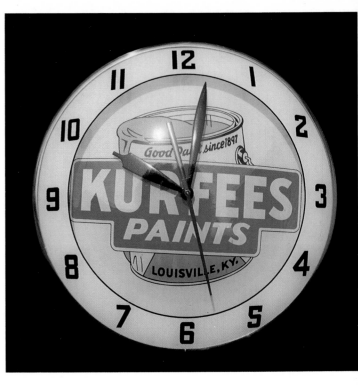

Hires Root Beer is one of America's oldest soft drink manufacturers. This circa 1950s clock was produced by Pam Clock Company. *Courtesy of Roger Blad.*

Advertising Products Incorporated manufactured this *"Double Bubble"* style clock for Kurfees Paints in the 1950s. The paint can with red marquee were their trademark. *Author's collection.*

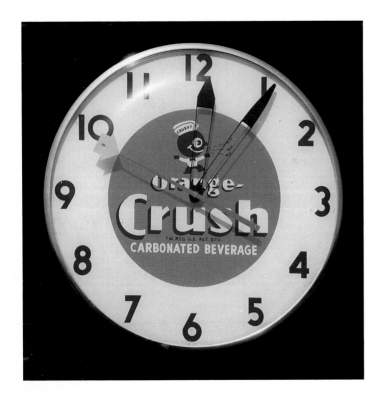

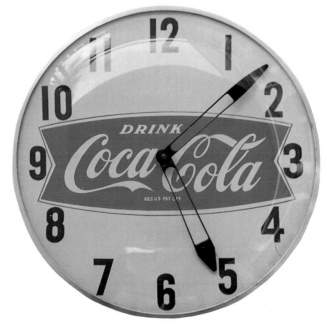

This Orange Crush clock dates to the late 1940s. It was produced by Telechron, and measures 14.5" in diameter. *Courtesy of Roger Blad.*

This Coca-Cola clock uses their well-known *"Fishtail"* logo. However, this one seems to be a scarce variety. Although no manufacturer is known, the time adjustment knob at the bottom would indicate it as being a product of Swihart. *Courtesy of Don Brunjes.*

Chapter 5
A Potpourri of Advertising Clocks

The following pages will present a broad spectrum of clocks that were manufactured in the years following 1930. Many of these had metal silk-screened dials, and all of them will have electric movements. The diversity found in these clocks was limited only by the imaginations of the companies that produced them.

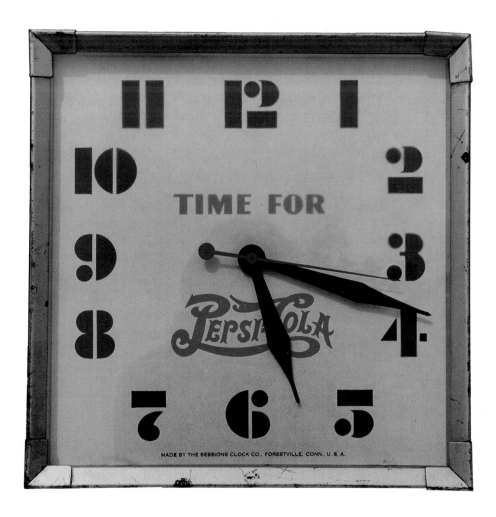

Sessions Clock Company was the manufacturer of this circa 1930s Pepsi-Cola clock. It measures 14.5" square. Notice the ornate logo with decorative lettering, as well as the two *"dots"* that are between the words Pepsi and Cola. This *"double dot"* logo dates the clock as an early vintage. *Courtesy of John H. Johnson.*

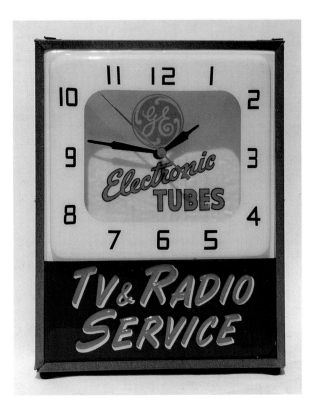

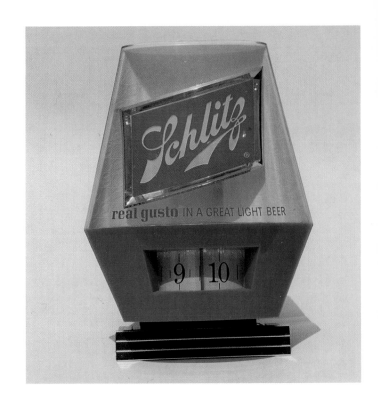

General Electric Tubes were the topic of this 1950s TV and Radio Service clock. It measures approximately 15" x 22". *Author's collection.*

"Futuristic" might be the best way to describe the design of this unusual Schlitz clock. It has a *"dial"* that is actually a cylinder with the hours on it. The photograph was taken with the time reading approximately 9:35. With all-plastic construction on this one, it dates to around 1965. *Author's collection.*

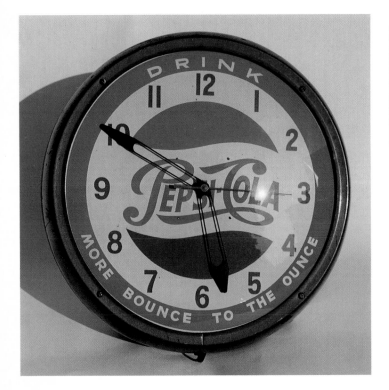

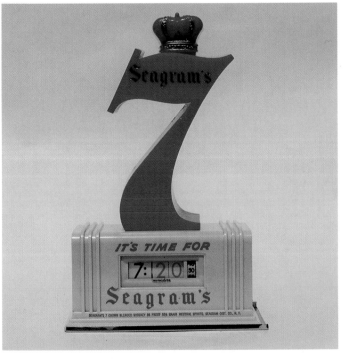

This circa 1950 Pepsi clock was manufactured by Duralite Displays. *Courtesy of Dan Wessel.*

Seagram's used this attractive molded plastic clock in the era around 1960. Notice that it was manufactured to give *"digital"* time. It has a light bulb in the large seven that sits on top of the clock. It measures approximately 9" x 14". *Author's collection.*

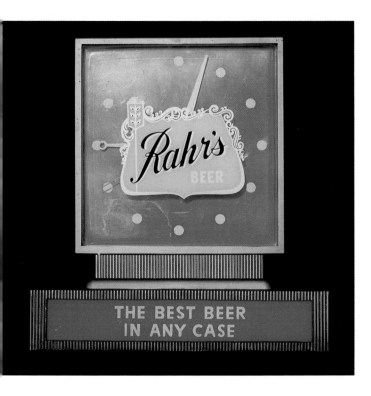

Rahr's Beer was manufactured in Oshkosh, Wisconsin. This countertop-size advertising clock has a marquee base for their slogan. It measures approximately 13" x 13". *Courtesy of Antique Mall of Manitowoc.*

The 1930s saw the production of this wood-framed Pepsi-Cola clock. It measures 15.5" x 15.5". *Courtesy of John H. Johnson.*

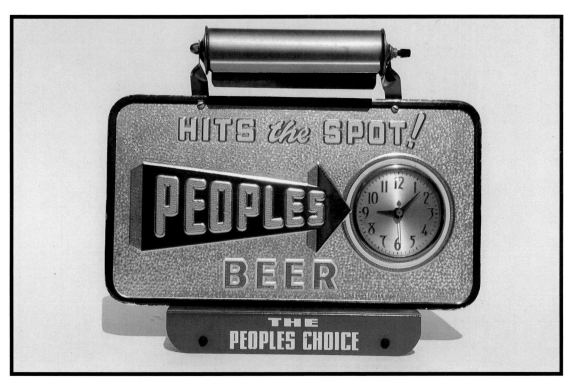

This eye-catching Peoples Beer countertop display clock is made of a pressed paper composition type backing. This was covered with a foil-like material that was fastened to the front. It measures approximately 14" x 10", and was produced around 1940. *Author's collection.*

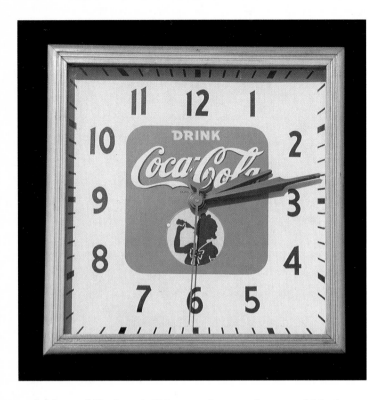

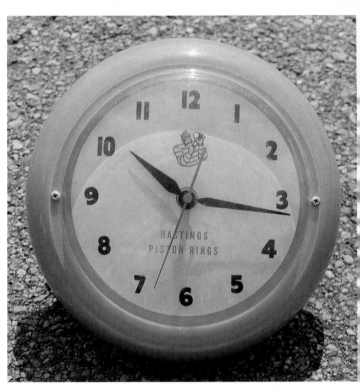

Lackner of Cincinnati, Ohio, was the manufacturer of this circa 1940s Coca-Cola clock. Lackner's popular style was to use wooden frames on a 16" square dial. *Courtesy of Darryl Tilden.*

Hastings Piston Rings used this small 7" diameter clock in the 1960s. It has an all-plastic body. *Courtesy of Vic and Sara Raupe.*

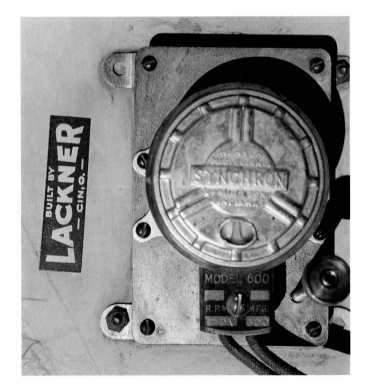

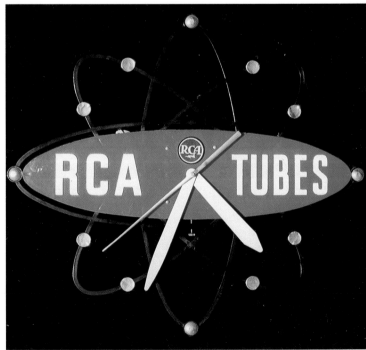

Here's a look at the back side of the Coca-Cola clock. Notice that Lackner used the standard of the industry — Synchron.

The 1950s saw the popularization of the *"atomic age."* This RCA Tubes clock kept up with the times with its nuclear design. It measures 20" in diameter. *Courtesy of Darryl Tilden.*

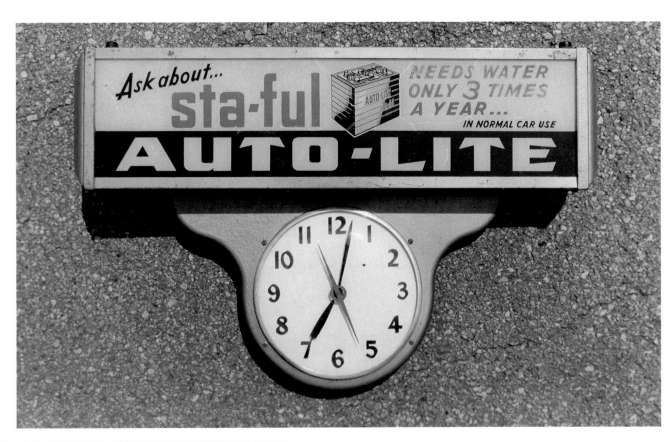

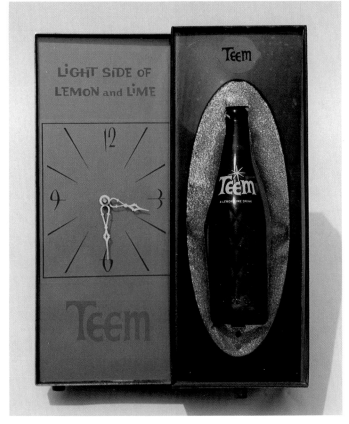

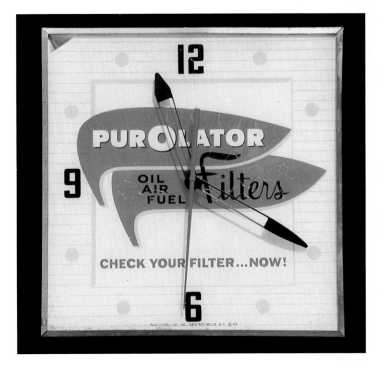

Auto-Lite had this marquee style clock produced for them in the 1940s. The unusual second hand gives you two choices. Notice the battery is of the six volt style. *Courtesy of Vic and Sara Raupe.*

Teem was a relatively short-lived soft drink that had its beginning in the 1960s. This unusual clock used a plastic bottle that was full-size on the right side of the clock. It measures 11" x 14". *Courtesy of John H. Johnson.*

This 16" square Pur-O-Later Filters clock dates to the 1960s. It was manufactured by Pam Clock Company. *Courtesy of Fox River Antique Mall.*

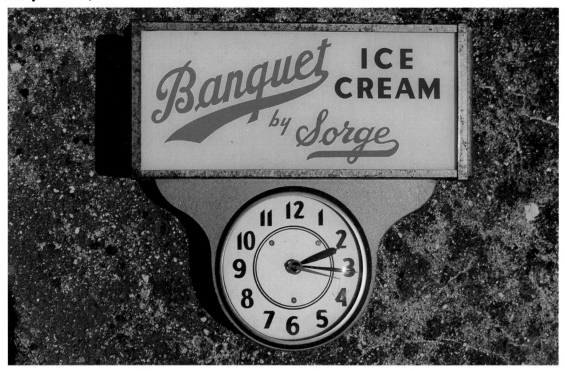

Banquet Ice Cream was made in **Manitowoc, Wisconsin. This** marquee style clock measures approximately 20" x 20", and was produced in the 1950s. *Courtesy of Red Barn Antiques.*

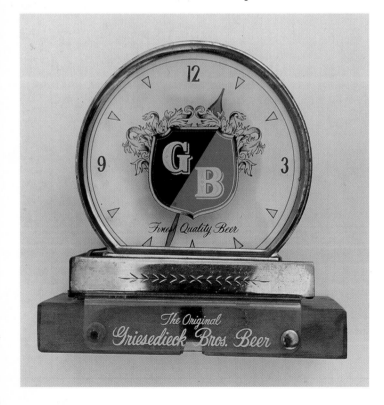

Griesedieck Brothers Beer had this advertisement in use around the 1940s. It has a light in the lower area that would illuminate the dial. It measures 10.5" x 10", and was built by Price Brothers. *Courtesy of Steve Perrigo.*

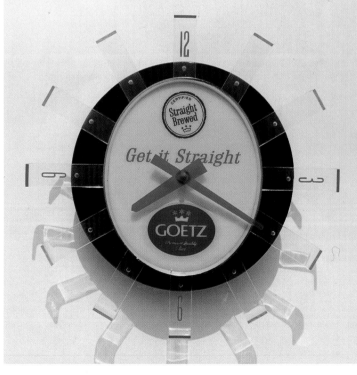

Thomas A. Schutz Company manufactured this clock for **Goetz** Beer in the 1960s. The dial used a series of plastic *"fingers"* that extended a couple inches from the body at each hour's position. These were bent up at the ends so that the illumination of the dial would carry through the plastic and light up the colored numbers as well as the ends. It's just one more example of the extremes that were used to attract attention to a manufacturer's product. It measures 14" in diameter. *Courtesy of Dan Oberholtz.*

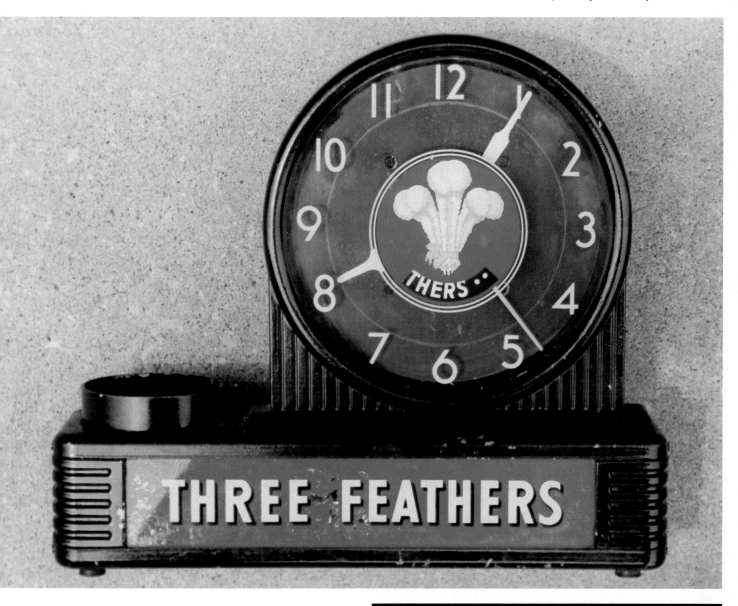

This Three Feathers clock had a lower marquee that was illuminated. The light from the marquee also lit up the dial. The round area at the left might appear to be an ashtray, but it originally held a display bottle of Three Feathers Beer. Notice that the dial has a center area with a rotating message that **was** viewed through the small window opening. This was part of the movement of the second hand. The clock was manufactured by Hammer Brothers of Chicago and New York, and measures 14" x 12". *Courtesy of Leslie and Donna Deason.*

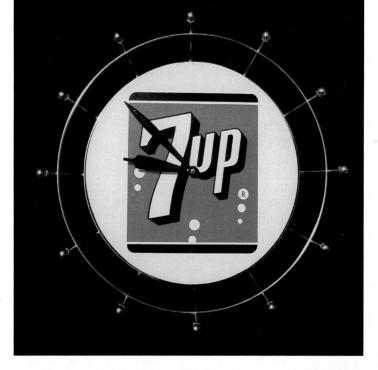

The 1950s saw the use of several designs of *"space age"* looking clocks. this 7-Up model was produced by Advertising Products of Cincinnati, Ohio. It measures 18" in diameter. *Courtesy of Darryl Tilden.*

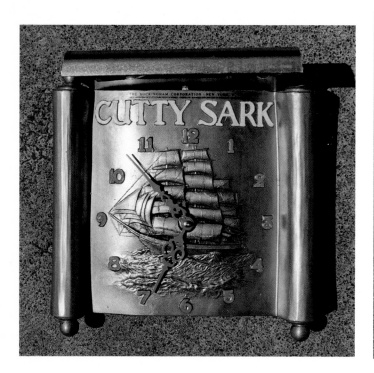

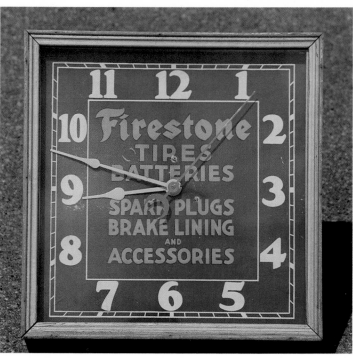

Cutty Sark had this lighted clock manufactured for them by The Buckingham Corporation of New York. It is constructed of die cast zinc. Although it appears that someone customized this clock with fluorescent paint, the author has found the identical paint job done on similar clocks in his travels. It measures approximately 11" x 11", and dates to the 1960s. *Courtesy of Robert Taylor at Retro Antiques.*

This wood-framed clock for Firestone was produced in the 1930s. It measures approximately 15" square. *Private collection.*

Old Milwaukee Beer was the focus of this circa 1960s *"ship"* clock. Although the clock dial itself did not light up, the rest of the advertising did, including the two plastic *"port"* and *"starboard"* lenses at the bottom. It measures approximately 15" x 12". *Courtesy of Old Towne Antique Mall.*

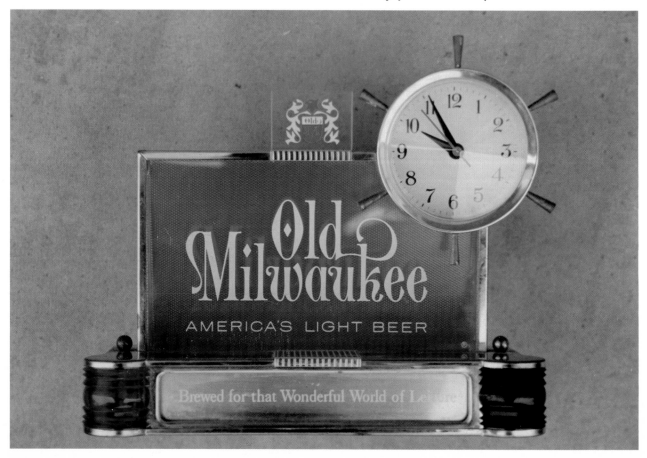

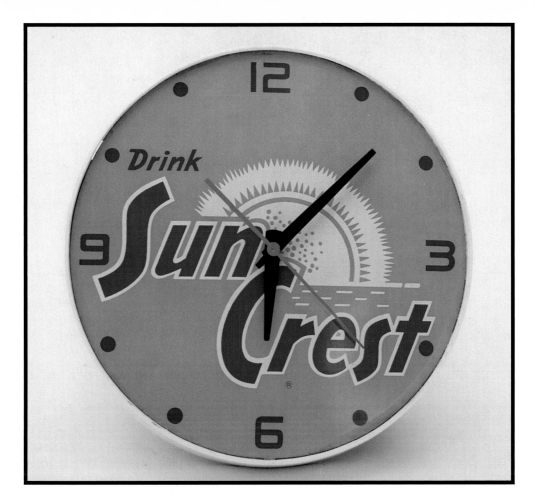

Sun Crest had this all-plastic clock produced in the 1960s. It measures approximately 8" in diameter. *Courtesy of Bill and Jane Wrenn.*

Gibbons Beer used this simple design to advertise their product in the 1950s. Plain and easy to read, it measures 14" in diameter. *Courtesy of Dick and Kathy Purvis.*

Quite a contrast in dial design exists between this Gibbons clock and the one in the previous photo. Both clocks date to the same time period, but it would be difficult to determine which clock was produced first. *Courtesy of Dick and Kathy Purvis.*

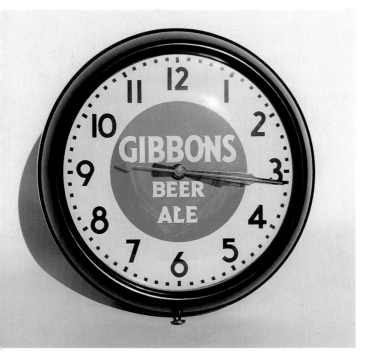

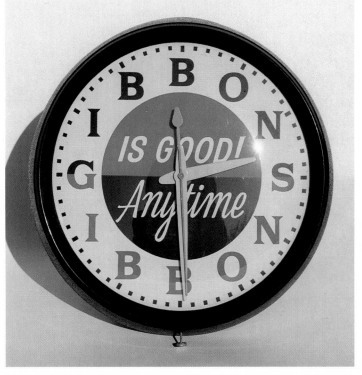

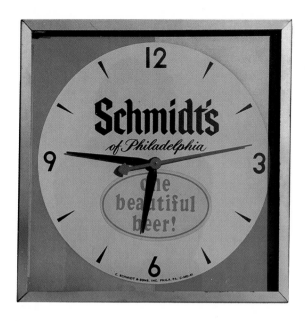

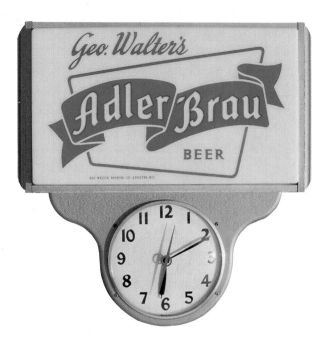

Schmidt's Beer had this 12" square clock produced for them in the 1950s. It has all-metal construction. *Courtesy of Dick and Kathy Purvis.*

George Walter's Adler-Brau Beer was brewed in Appleton, Wisconsin. This metal body clock with a plastic advertising marquee dates to the 1940s, and measures approximately 22" square. *Courtesy of Fox River Antique Mall.*

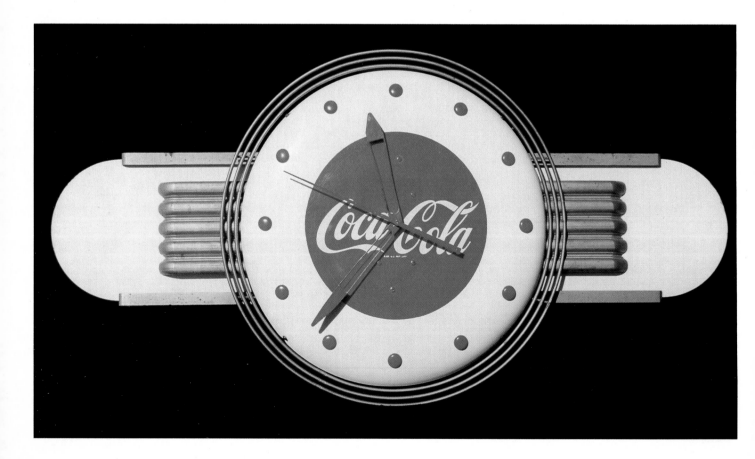

Coca-Cola used this *"ballroom"* style clock in the 1950s. it measures 36" x 19". *Courtesy of Darryl Tilden.*

This advertisement for Marlboro and Philip Morris cigarettes dates to the era around 1960. It measures 11" x 28", and has all-metal construction. *Courtesy of Dick and Kathy Purvis.*

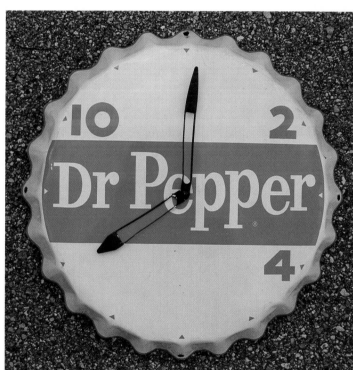

Dr. Pepper used this *"bottle cap"* style clock in the era around 1960. It has all-metal construction, and measures approximately 15" in diameter. *Courtesy of Fox River Antique Mall.*

Who said advertising clocks had to be the same? This rather large Vernors wrist watch style clock is a big one, measuring approximately 40" long, and uses a quartz movement. *Courtesy of Jim Humphrey.*

The 1930s saw the introduction of Pepsi-Cola into the mineral water business. This rare advertisement for Cloverdale Mineral Water is featured on a 15" square wood-frame clock. although no manufacturer has left their name for posterity, no doubt the clock was manufactured by Selected Device Company of New York. *Courtesy of John H. Johnson.*

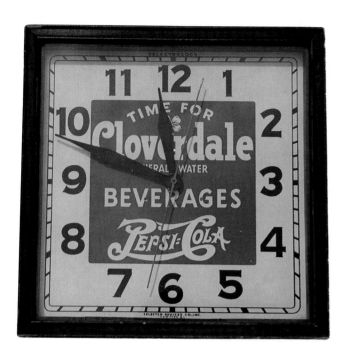

Here's a somewhat different Cloverdale clock. This time with an all-green logo. It dates to the 1930s, and has a dial that shows Selected Devices as the manufacturer. This one uses the same wood-frame construction as the other Cloverdale clock, but it measures slightly larger at 15.5" square. *Courtesy of John H. Johnson.*

Railroads were always interested in accurate time. However, few clocks have been found with any railroad advertising on them. This utilitarian-looking Rock Island clock measures approximately 14" in diameter, and was produced in the 1940's. *Courtesy of Railroad Memories Museum.*

This label is on the back side of the green logo Cloverdale clock. *Courtesy of John H. Johnson.*

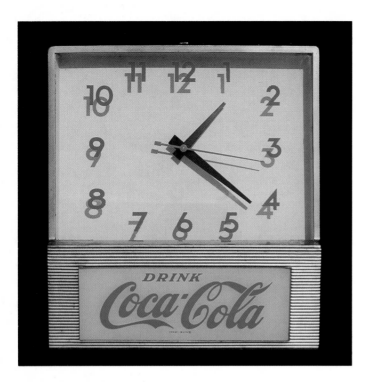

A gold metallic finish was given to this circa 1950s Coca-Cola clock. The marquee on the bottom was back-lighted. It measures approximately 14" x 15". *Courtesy of Fox River Antique Mall.*

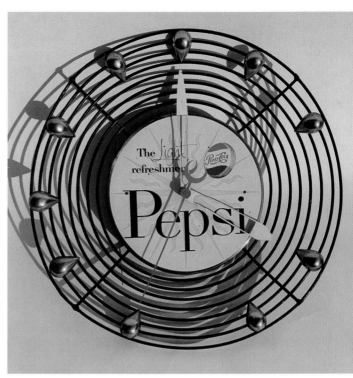

The 1950s saw several manufacturers using *"futuristic"* designs in advertising clocks. This Pepsi example was produced by Holzer Display Incorporated of New York, and measures approximately 22" in diameter. *Courtesy of Dan and Nancy Wessel.*

Economical would best describe the cost to produce this circa 1950s Old German Beer clock. It was manufactured of a thin *"pie-dish"* type body, and a paper label dial did the rest. It measures approximately 15" in diameter. *Private collection.*

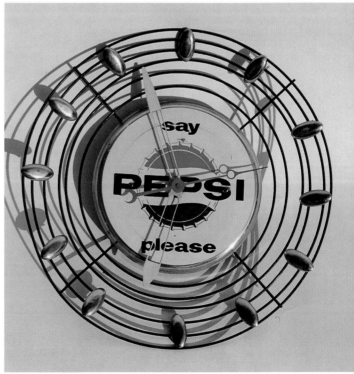

This similar wire frame clock was produced by the same manufacturer, but dates to the early 1960s. *Courtesy of Dan and Nancy Wessel.*

Whistle soft drinks were the theme on this fantastic stand-up display clock. It was produced in 1948 by the Phelps Manufacturing Company of Terre Haute, Indiana. It is constructed of a masonite-type board that is painted, and measures 24" x 24", *Courtesy of Dan and Nancy Wessel.*

This label is attached to the back of the Whistle clock. *Courtesy of Dan and Nancy Wessel.*

WHISTLE CLOCK
No. WC6-92

1. A hook hanger is furnished - place same in wall at desired position - then hang clock.
2. Plug into electrical outlet.
3. This clock movement will not function when connected to direct current - connect only to - ALTERNATING CURRENT - 110 volts - 60 cycle.
4. Set correctly by carefully moving the minute hand forward. Movement is self starting.
5. Clock movement is guaranteed - advise if same does not keep accurate time.

Union Made By
PHELPS MANUFACTURING COMPANY
TERRE HAUTE, INDIANA

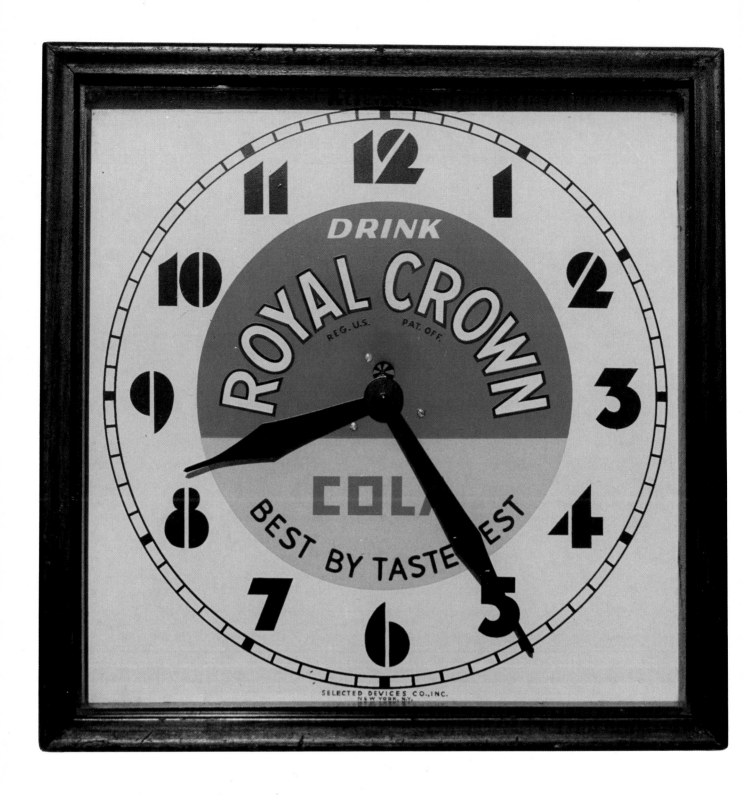

Selected Devices produced this beautiful Royal Crown Cola
clock in the 1930s. There's nothing like deco looking dial
numbers to help date a clock. Notice the small *"spinner"* just
above the dial's center. This was in motion when the clock was
running. *Author's collection.*

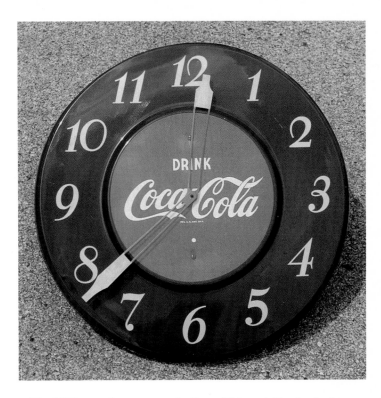

Tetley Tea used this 14" square clock in the 1940s. It has an all-metal body. *Courtesy of Dave Higgs.*

The 1950s saw the mass production of this metal body clock for Coca-Cola. It measures approximately 18" in diameter, and can also be found in a somewhat less common variety that has silver paint as the background color on the dial. *Private collection.*

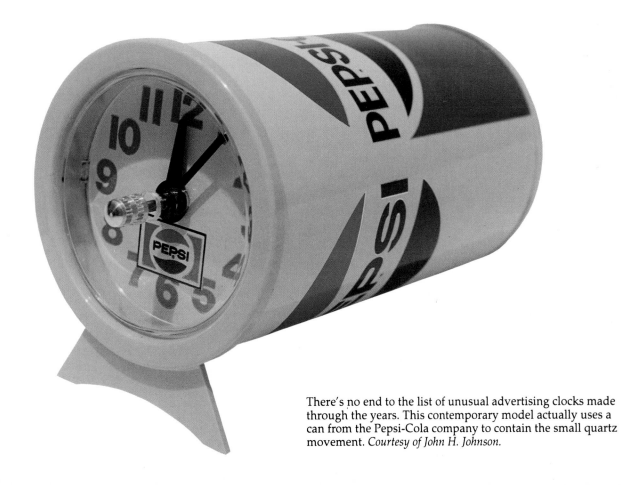

There's no end to the list of unusual advertising clocks made through the years. This contemporary model actually uses a can from the Pepsi-Cola company to contain the small quartz movement. *Courtesy of John H. Johnson.*

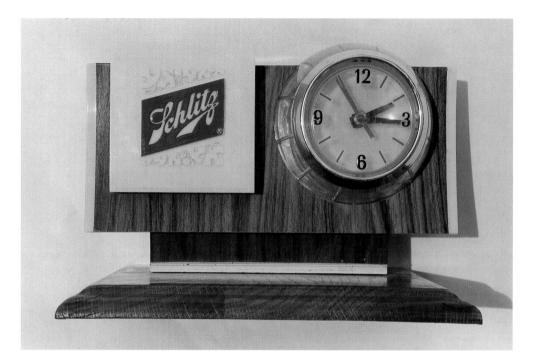

Several types of advertising used by the Schlitz Brewing Company featured a see-through plastic *"keg."* This circa 1960s clock uses that theme, and has a fluorescent tube lighting the marquee as well as the dial. It measures 11" x 7". *Courtesy of Topeka Antique Mall.*

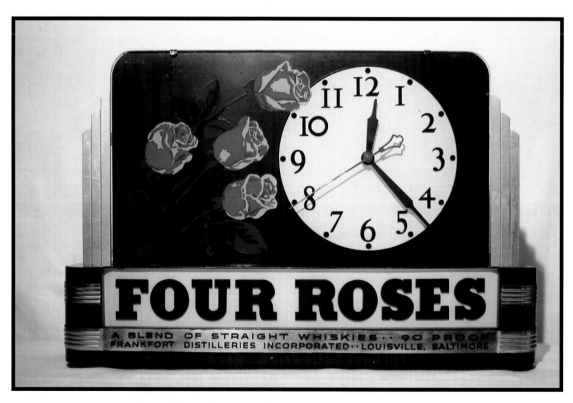

Beautiful graphics adorn this 1940s Four Roses advertising clock. The marquee was back-lit with incandescent bulbs. The dial is part of the glass that has the silk-screened flowers, and this would light up as well. It measures approximately 14" x 9". *Courtesy of Ken Baisa at Ken-Glo Clocks.*

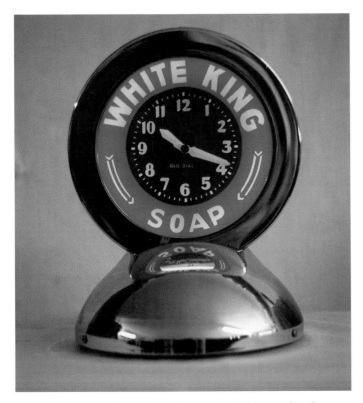

White King Soap is featured on this unusual chrome plated clock from the 1930s. It measures approximately 8" x 11". *Courtesy of Ken Baisa at Ken-Glo Clocks.*

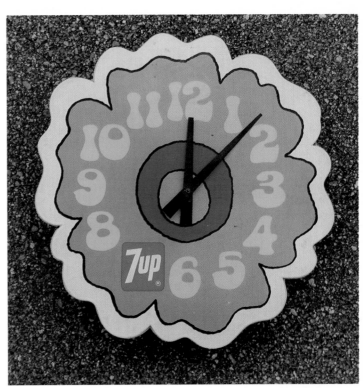

Psychedelic might be the best way to describe this wild 7-Up clock. Not too much guesswork involved to date this one to around 1970. It's fairly obvious what market 7-Up was trying to target. It has a masonite type dial construction that is painted, and it measures approximately 14" in diameter. *Private collection.*

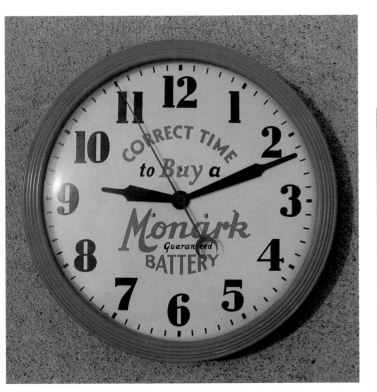

A bright red wooden frame was used on this Monark Battery clock. It was produced in the 1930s by an unknown manufacturer, and uses a Hammond mechanism. *Courtesy of Automobile Collectibles.*

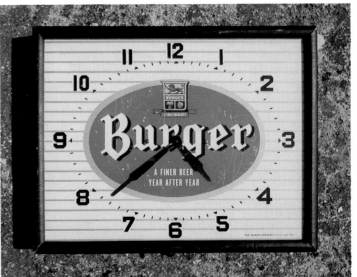

Burger Beer was produced in Cincinnati, Ohio, but where this metal dial clock was made remains a mystery. It measures approximately 17" x 13", and dates to the 1950s. *Courtesy of Red Barn Antiques.*

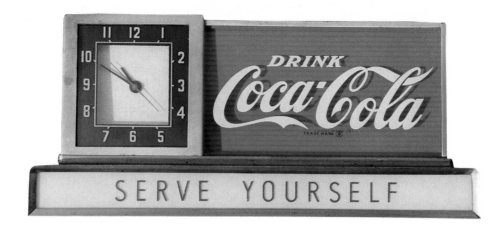

Here's another example of the many creative ways that Coca-Cola advertised its product. The unit shown here has a back-lit marquee on the base, which also fed light to the upper areas, including the clock dial. It measures approximately 19" x 8", and dates to the 1950s. *Private collection.*

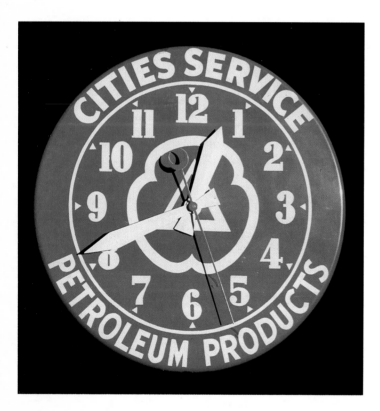

Cities Service had thousands of advertising items manufactured for them through the years. This all-metal body clock scores high on the list with collectors. It measures 19" in diameter, and was produced by Modern Clock Company of Chicago, Illinois, around the 1940s. *Courtesy of Gene Sonnen.*

Although this advertisement for Clock Ale and Lager will never give you the time, it's been included here for your enjoyment. This 12" diameter beer tray was produced by the Electro Chemical Engraving Company of New york, and dates to 1936. *Courtesy of Dick and Kathy Purvis.*

All-plastic construction was used on this circa 1950s
Knickerbocker Beer clock. The photograph used in the mar-
quee was easily interchanged. It measures approximately 18" x
8", and was lighted inside. *Courtesy of Randy Reith at The Last
Filling Station.*

Leinenkugel's was a Mid-West favorite for years and to this
day they are still going strong. This circa 1940 clock has a large
overhead marquee that is typical of those manufactured by The
Ohio Advertising Display Company of Cincinnati. It measures
26" x 17". You might be able to notice that the Indian Maiden
trademark has been slightly refined over the years, by viewing
their *"Double Bubble"* clock of the 1950s in chapter four.
Courtesy of Darryl Tilden.

The Ohio Advertising Display Company placed these decals
on the back side of their products.

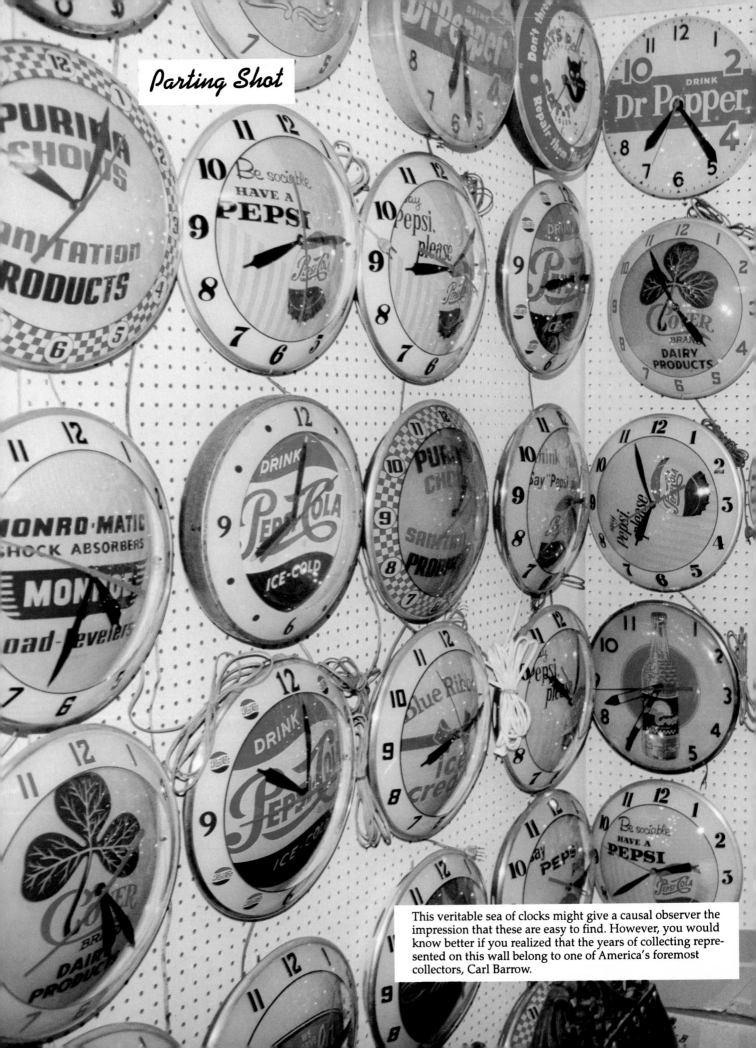

Parting Shot

This veritable sea of clocks might give a causal observer the impression that these are easy to find. However, you would know better if you realized that the years of collecting represented on this wall belong to one of America's foremost collectors, Carl Barrow.